VISION AND VISUALITY

Dia Art Foundation
Discussions in Contemporary Culture
Number 2

VISION AND VISUALITY

Edited by Hal Foster

BAY PRESS SEATTLE 1988

Printed in the United States of America
99 98 97 7 6 5 4

Bay Press
115 West Denny Way
Seattle, Washington 98119

Design by Bethany Johns
Typesetting by Sarabande, New York
Printed by Walsworth Publishing Company, Marceline, Missouri
Set in Perpetua

Library of Congress Cataloging-in-Publication Data
(Revised for vol. 2)

Discussions in Contemporary Culture.

No. 1–2 edited by Hal Foster.
Includes bibliographies.
Contents: no. 1 [without special title]–no. 2.
Vision and Visuality.
1. Art and society. 2. Aesthetics, Modern–20th century.
I. Foster, Hal. II. Dia Art Foundation.
N72.S6D57 1987 700'.1'03 87-71579
ISBN: 978-1-565844-61-2

CONTENTS

In 1987, the Dia Art Foundation initiated its commitment to critical discussion and debate through a series of six weekly discussions on diverse cultural topics organized by Hal Foster. Edited transcripts of these discussions together with prepared texts were presented in the first volume of an ongoing series of publications called Discussions in Contemporary Culture. The series is intended to record aspects of the organized discussion events held at Dia from time to time, primarily at its downtown space at 155 Mercer Street, New York.

This volume, Number 2 in the Discussions in Contemporary Culture series, includes texts prepared by the participants in a day-long symposium held on April 30, 1988, at Dia's exhibition space at 548 West 22nd Street, together with edited transcripts of discussions with the audience following the presentations of the participants. The symposium was generally an exploration of modes of vision; the presenters explained different ways in which what is seen is revised, through various social, psychological, and biological filters, before it is perceived. Characteristics of different models of seeing are shown to evolve historically, and recently in reaction to models specifically associated with the principles of modernism. Most but not all of these analyses centered around the production and perception of visual art. Hal Foster, who organized the symposium and edited this volume, explains in his preface something of the topicality of new critical attention to theories of vision.

We are grateful to Hal Foster for his work on this book and for his conception and organization of the Vision and Visuality symposium, which was attended by a diverse and, as is evident in the discussion portions of this book, keenly engaged audience. We also thank the five participants in the symposium for their excellent presentations that day and for their helpful

texts. This book also reflects the careful production work of Phil Mariani, Bethany Johns, and Ellen Foos, and of Thatcher Bailey at Bay Press.

We look forward to a series of events in 1988-89 centered around critical discussion and to additional volumes of this publication series.

Charles Wright
Executive Director
Dia Art Foundation

Hal Foster

Why vision and visuality, why these terms? Although vision suggests sight as a physical operation, and visuality sight as a social
fact, the two are not opposed as nature to culture: vision is social and historical too, and visuality involves the body and the
psyche. Yet neither are they identical: here, the difference between the terms signals a difference within the visual—between
the mechanism of sight and its historical techniques, between
the datum of vision and its discursive determinations—a difference, many differences, among how we see, how we are able,
allowed, or made to see, and how we see this seeing or the unseen therein. With its own rhetoric and representations, each
scopic regime seeks to close out these differences: to make of its
many social visualities one essential vision, or to order them in a
natural hierarchy of sight. It is important, then, to slip these superimpositions out of focus, to disturb the given array of visual
facts (it may be the only way to see them at all), and this little
book suggests ways to do this for the modern period. Thus the
general project in which it partakes: to thicken modern vision,
to insist on its physiological substrate (Jonathan Crary) *and* on its
psychic imbrication (whether this is seen in terms of vicissitude
[Jacqueline Rose] or subversion [Rosalind Krauss]); to socialize
this vision, to indicate its part in the production of subjectivity
(all the authors) *and* its own production as a part of intersubjectivity (a dialectic of the gaze in which, according to one "paranoid" model, the subject is menaced by its other [Norman
Bryson]); and, in general, to historicize modern vision, to specify its dominant practices *and* its critical resistances (Martin Jay

explicitly, the others implicitly). To complicate matters, there emerged in the symposium a criticism of this general critique, and a call for an alternative to the search for alternative visual regimes.

But why this topic, or these takes, now? This is more difficult to answer, for "causes" are always too little or too much, and "preconditions" too thick or too thin. It is, however, no secret that several strong critiques of modern(ist) models of vision have developed: e.g., critiques of the "Cartesian perspectivalism" which separates subject and object, renders the first transcendental and the second inert, and so subtends metaphysical thought, empirical science, and capitalist logic all at once; or critiques of the categorical separation of artistic expression which, complicit with this modern rationalism even as it is critical of it, privileges the purely optical in visual art, to which formal principle painting is periodically disciplined. Here, in turn, Martin Jay points to cracks within traditional perspective — conflicts in practice, paradoxes in logic (e.g., perspective seen as empirically true and universally valid versus perspective as conventional and contingent — "a symbolic form," in the famous phrase of Panofsky); he also poses critical variants, even countertraditions: an "art of describing" (the term is Svetlana Alpers's) which emerges in seventeenth-century Dutch painting based on cartographic principles; and a "madness of vision" (or *folie du voir*) which is developed in baroque art that flaunts the opacity of sublime subjects and underscores the rhetorical conventionality of sight. For Jay, each practice extends beyond its own historical formation: not only is the first said to operate in certain modernist forms, but the second is seen now to challenge Cartesian perspectivalism for cultural primacy in the postmodern West.

Jonathan Crary also rejects any reading of Cartesian perspectivalism as consistent or continuous. In fact, he locates its theoretical displacement in the early nineteenth century, with the shift from geometrical optics to a physiological account of

vision—from the paradigm of the camera obscura, of a veridical vision of bipolar subject and object, to the model of the body as producer of a nonveridical vision relatively indifferent to worldly reference. Immediately this history estranges familiar others: one is forced to revise or reject, on the one hand, any linear narrative of technical progression (from camera obscura to photography) and, on the other hand, any simple concept of historical break (as if modernist abstraction had heroically, on its own and from above, voided perspectivalism). Moreover, one is left to wonder at the sheer perseverance of perspectivalism as an epistemological model. However, rather than celebrate the physiological account—as, say, a precondition of the modernist autonomy of the visual, or abstractly as a basis for a new freedom or a higher truth—Crary refers it to the construction of the modern subject, the reconfiguration of vision, of the senses, of the body as objects of science and agents of work. (Incidentally, this discussion implies a crucial theoretical caution for art history: not only, on the one hand, not to presuppose an essential viewer but also, on the other hand, not to historicize the viewer too strictly in terms of cultural forms—as if the viewer had no other site of formation, as if these forms somehow existed prior to the subject, as if they were not also complexly produced.)

In her paper, Rosalind Krauss explores an optical unconscious in modernism, here as tapped by Duchamp, Ernst, Giacometti, and others. This intuition about the visual is sensitive to its involvement with corporeal desire; it thus runs counter to the relative rarefaction (or reification) of vision, evident elsewhere in modernism, as a domain "of pure release, of pure transparency, of pure self-knowledge." In effect, Krauss considers the ramifications, for this countertradition, of the physiological concept of the visual detailed by Crary, as well as of the psychoanalytical concept of its *mises-en-scène* discussed by Bryson and Rose. In particular, she argues that there exists a beat, pulse,

or rhythm, a "matrix" of the visual which, not restricted to space or time, to high culture or low, serves to confound such categories of form, to undo such distinctions of vision dear to much art and cultural history. In her portrait of Picasso, this dysmorphic aspect of vision is exposed in an oeuvre celebrated for its formal invention.

With Norman Bryson, vision is again regarded as corrosive—to subjectivity. In its guise as the gaze of the other, vision, according to Sartre and Lacan, decenters the subject; yet in this scheme, Bryson argues, the centered subject remains residual—in protest, as it were. This threatened remainder leads Sartre and Lacan variously to present the gaze in paranoid terms, as an event which persecutes, even annihilates the subject. In certain Eastern philosophies, Bryson maintains, the decentering of the subject is more complete. More importantly, it is welcomed rather than resisted; thus the gaze is not regarded as a terror. This has significant consequences for the construction of subjectivity and its spaces, for the conception of art and its techniques, some of which Bryson explores. He does not, however, pose this other tradition as an alternative open to our appropriation (which was nonetheless a contested tendency of the discussion), but rather as a way to denature our habitual practices of the visual—to prepare, in short, a politics of sight. For, finally, it is not that the gaze is not experienced as menace in our culture, but that this menace is a social product, determined by power, and not a natural fact. "To think of a terror intrinsic to sight makes it harder to think what *makes* sight terroristic, or otherwise."

Jacqueline Rose also finds a psychic trope operative in discussions of vision, particularly in accounts of postmodernism that propose as its prime attribute a new formation of space. These accounts (she mentions Jameson, Deleuze and Guattari, Lyotard) present postmodernism in terms of a crisis in social totality; whether celebrated or lamented, this crisis is often figured

in terms of a breakdown in psychic life: the social as schizo-phrenic. Rose questions this use of psychoanalysis; specifically, she argues, no sooner is its notion of schizophrenia evoked than its negativities evaporate: sexual difference tends to be elided (with feminism "disenfranchised") and psychic life to be distilled (with its "anguish" taken as our "pleasure"). This "innocenting" of the sexual and the psychical, Rose maintains, involves an in-nocenting of the visual, as if there existed some immediate vi-sion before this schizoid sight. Theoretically problematic, the schizo-trope, she concludes, may also be politically dangerous, especially in the face of a repressive right which taps the uncon-scious for its own fantasms of terror and desire.

No one set of preconditions governs this range of argu-ment; there are, however, discourses held in common. Certainly the entire discussion draws on analyses of the subject and the image derived from poststructuralism and psychoanalysis; in fact, vision is investigated as a structure instrumental to the (dis)placement of both these terms. In this regard, the feminist attention to the psychic imbrication of the sexual and the visual is especially important, as is the semiological sensitivity to the visual as a field of signs produced in difference and riven by de-sire. These insights have begun to produce, as is evident here, a deconstruction of "perceptualist" art history in general and "formalist" art theory in particular. In this respect, the discus-sion is also allied with a certain "anti-foundational" critique, i.e., a critique of the historical concepts posited by a discipline (e.g., art history, for instance) as its natural epistemological grounds. The contemporary rage to historicize is also crucial, for the *sine qua non* of this discussion is the recognition that vi-sion *has* a history, that there are different regimes of visuality. (The concern with a "political unconscious" of vision and an "archaeology" of its formations may suggest the contested influ-ences of Jameson and Foucault.) One hesitates to speculate on more worldly conditions; they will be specific to each reader.

However, the virulence in the Western metropolis of sexist, heterosexualist, and racist gazes, deepened by a reactive patriarchy and a divisive political economy, cannot help but inflect the discussion and inform its reception. The same is true of the visual technorama which envelops most of us with new technologies of the image and new techniques of the subject-in-sight.

One last comment. The critique of perspectivalism, the concern with corporeal vision, the analysis of the gaze—these things are not new. Decades have passed since Panofsky pointed to the conventionality of perspective, and Heidegger to its complicity with a subject willed to mastery; years since Merleau-Ponty stressed the bodiliness of sight, Lacan the psychic cost of the gaze, and Fanon its colonialist import. Yet significant differences distinguish the present discussion; one is its partial questioning of these prior analyses. Thus Rose asks what positive terms are set up by such critique (e.g., do we want to seek an alternative visual realm in the unconscious if this is to privilege psychic disturbance?), and Jay cautions against the celebration of a postmodern *folie du voir* (e.g., what is lost with the distance granted by perspective?). Such questioning is not intended to correct modern analyses of vision but precisely to keep them critical—to *not* turn partial tendencies into whole traditions, plural differences into a few static oppositions. On this point, too, there emerged a critique of the search for alternative visualities, whether these are to be located in the unconscious or the body, in the past (e.g., the baroque) or in the non-West (e.g., Japan), and it emerged for similar reasons: not to foreclose such differences, but to open them up, so that alternatives might not be merely appropriated as the same *or* strictly distanced as other—so that different visualities might be kept in play, and difference in vision might remain at work.

VISION AND VISUALITY

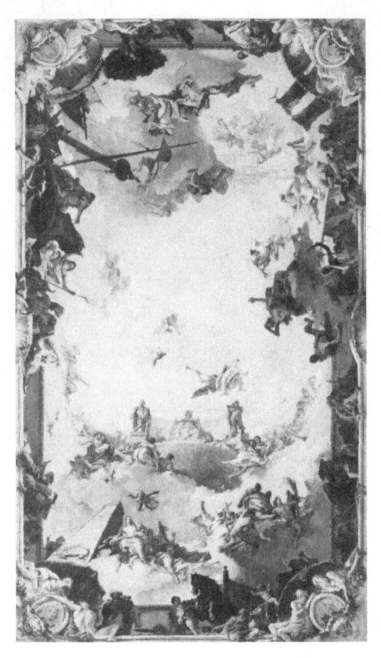

Giovanni Battista Tiepolo. *The World Pays Homage to Spain,* 1762–64. Washington, D.C., National Gallery of Art, Samuel H. Kress Collection. (Courtesy National Gallery of Art)

Martin Jay

SCOPIC REGIMES OF MODERNITY

The modern era, it is often alleged,[1] has been dominated by the sense of sight in a way that set it apart from its premodern predecessors and possibly its postmodern successor. Beginning with the Renaissance and the scientific revolution, modernity has been normally considered resolutely ocularcentric. The invention of printing, according to the familiar argument of McLuhan and Ong,[2] reinforced the privileging of the visual abetted by such inventions as the telescope and the microscope. "The perceptual field thus constituted," concludes a typical account, "was fundamentally nonreflexive, visual and quantitative."[3]

Although the implied characterization of different eras in this generalization as more favorably inclined to other senses should not be taken at face value,[4] it is difficult to deny that the visual has been dominant in modern Western culture in a wide variety of ways. Whether we focus on "the mirror of nature" metaphor in philosophy with Richard Rorty or emphasize the prevalence of surveillance with Michel Foucault or bemoan the society of the spectacle with Guy Debord,[5] we confront again and again the ubiquity of vision as the master sense of the modern era.

But what precisely constitutes the visual culture of this era is not so readily apparent. Indeed, we might well ask, borrowing Christian Metz's term, is there one unified "scopic regime"[6] of the modern or are there several, perhaps competing ones? For, as Jacqueline Rose has recently reminded us, "our previous history is not the petrified block of a single visual space since, looked at obliquely, it can always be seen to contain its moment

of unease."[7] In fact, may there possibly be several such moments, which can be discerned, if often in repressed form, in the modern era? If so, the scopic regime of modernity may best be understood as a contested terrain, rather than a harmoniously integrated complex of visual theories and practices. It may, in fact, be characterized by a differentiation of visual subcultures, whose separation has allowed us to understand the multiple implications of sight in ways that are now only beginning to be appreciated. That new understanding, I want to suggest, may well be the product of a radical reversal in the hierarchy of visual subcultures in the modern scopic regime.

Before spelling out the competing ocular fields in the modern era as I understand them, I want to make clear that I am presenting only very crude ideal typical characterizations, which can easily be faulted for their obvious distance from the complex realities they seek to approximate. I am also not suggesting that the three main visual subcultures I single out for special attention exhaust all those that might be discerned in the lengthy and loosely defined epoch we call modernity. But, as will soon become apparent, it will be challenging enough to try to do justice in the limited space I have to those I do want to highlight as most significant.

Let me begin by turning to what is normally claimed to be the dominant, even totally hegemonic, visual model of the modern era, that which we can identify with Renaissance notions of perspective in the visual arts and Cartesian ideas of subjective rationality in philosophy. For convenience, it can be called Cartesian perspectivalism. That it is often assumed to be equivalent to the modern scopic regime per se is illustrated by two remarks from prominent commentators. The first is the claim made by the art historian William Ivins, Jr., in his *Art and Geometry* of 1946 that "the history of art during the five hundred years that have elapsed since Alberti wrote has been little more than the story of the slow diffusion of his ideas through the artists and

peoples of Europe."[8] The second is from Richard Rorty's widely discussed *Philosophy and the Mirror of Nature*, published in 1979: "in the Cartesian model the intellect *inspects* entities modeled on retinal images. . . . In Descartes' conception—the one that became the basis for 'modern' epistemology—it is *representations* which are in the 'mind.'"[9] The assumption expressed in these citations that Cartesian perspectivalism is *the* reigning visual model of modernity is often tied to the further contention that it succeeded in becoming so because it best expressed the "natural" experience of sight valorized by the scientific world view. When the assumed equivalence between scientific observation and the natural world was disputed, so too was the domination of this visual subculture, a salient instance being Erwin Panofsky's celebrated critique of perspective as merely a conventional symbolic form.[10]

But for a very long time Cartesian perspectivalism was identified with the modern scopic regime *tout court*. With full awareness of the schematic nature of what follows, let me try to establish its most important characteristics. There is, of course, an immense literature on the discovery, rediscovery, or invention of perspective—all three terms are used depending on the writer's interpretation of ancient visual knowledge—in the Italian Quattrocento. Brunelleschi is traditionally accorded the honor of being its practical inventor or discoverer, while Alberti is almost universally acknowledged as its first theoretical interpreter. From Ivins, Panofsky, and Krautheimer to Edgerton, White, and Kubovy,[11] scholars have investigated virtually every aspect of the perspectivalist revolution, technical, aesthetic, psychological, religious, even economic and political.

Despite many still disputed issues, a rough consensus seems to have emerged around the following points. Growing out of the late medieval fascination with the metaphysical implications of light—light as divine *lux* rather than perceived *lumen*—linear perspective came to symbolize a harmony between the mathe-

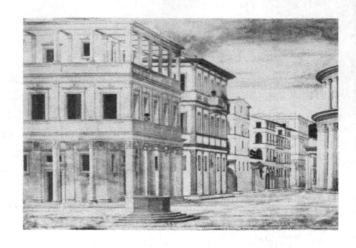

matical regularities in optics and God's will. Even after the religious underpinnings of this equation were eroded, the favorable connotations surrounding the allegedly objective optical order remained powerfully in place. These positive associations had been displaced from the objects, often religious in content, depicted in earlier painting to the spatial relations of the perspectival canvas themselves. This new concept of space was geometrically isotropic, rectilinear, abstract, and uniform. The *velo* or veil of threads Alberti used to depict it conventionalized that space in a way that anticipated the grids so characteristic of twentieth-century art, although, as Rosalind Krauss has reminded us, Alberti's veil was assumed to correspond to external reality in a way that its modernist successor did not.[12]

The three-dimensional, rationalized space of perspectival vision could be rendered on a two-dimensional surface by following all of the transformational rules spelled out in Alberti's *De Pittura* and later treatises by Viator, Dürer, and others. The basic device was the idea of symmetrical visual pyramids or cones with one of their apexes the receding vanishing or centric point in the painting, the other the eye of the painter or the beholder. The transparent window that was the canvas, in Alberti's

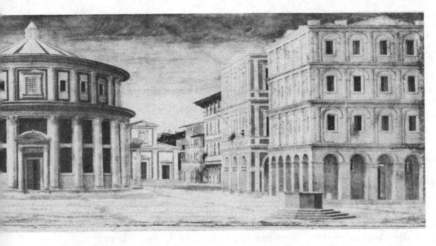

School of Piero della Francesca. *View of an Ideal City*, 1470(?). Urbino, Palazzo Ducale. (Courtesy Art Resource, N.Y.)

famous metaphor, could also be understood as a flat mirror reflecting the geometricalized space of the scene depicted back onto the no less geometricalized space radiating out from the viewing eye.

Significantly, that eye was singular, rather than the two eyes of normal binocular vision. It was conceived in the manner of a lone eye looking through a peephole at the scene in front of it. Such an eye was, moreover, understood to be static, unblinking, and fixated, rather than dynamic, moving with what later scientists would call "saccadic" jumps from one focal point to another. In Norman Bryson's terms, it followed the logic of the Gaze rather than the Glance, thus producing a visual take that was eternalized, reduced to one "point of view," and disembodied. In what Bryson calls the "Founding Perception" of the Cartesian perspectivalist tradition,

the gaze of the painter arrests the flux of phenomena, contemplates the visual field from a vantage-point outside the mobility of duration, in an eternal moment of disclosed presence; while in the moment of viewing, the viewing subject unites his gaze with the Founding Perception, in a moment of perfect recreation of that first epiphany.[13]

A number of implications followed from the adoption of this vi-
sual order. The abstract coldness of the perspectival gaze meant
the withdrawal of the painter's emotional entanglement with the
objects depicted in geometricalized space. The participatory in-
volvement of more absorptive visual modes was diminished, if
not entirely suppressed, as the gap between spectator and spec-
tacle widened. The moment of erotic projection in vision—what
St. Augustine had anxiously condemned as "ocular desire"[14]—
was lost as the bodies of the painter and viewer were forgotten
in the name of an allegedly disincarnated, absolute eye. Although
such a gaze could, of course, still fall on objects of desire—
think, for example, of the female nude in Dürer's famous print
of a draftsman drawing her through a screen of perspectival
threads[15]—it did so largely in the service of a reifying male look
that turned its targets into stone. The marmoreal nude drained
of its capacity to arouse desire was at least tendentially the out-
come of this development. Despite important exceptions, such as
Caravaggio's seductive boys or Titian's *Venus of Urbino*, the nudes
themselves fail to look out at the viewer, radiating no erotic en-
ergy in the other direction. Only much later in the history of
Western art, with the brazenly shocking nudes in Manet's *Dé-
jeuner sur l'herbe* and *Olympia,* did the crossing of the viewer's
gaze with that of the subject finally occur. By then the ra-
tionalized visual order of Cartesian perspectivalism was already
coming under attack in other ways as well.

In addition to its de-eroticizing of the visual order, it had
also fostered what might be called de-narrativization or de-tex-
tualization. That is, as abstract, quantitatively conceptualized
space became more interesting to the artist than the qualitatively
differentiated subjects painted within it, the rendering of the
scene became an end in itself. Alberti, to be sure, had empha-
sized the use of perspective to depict *istoria,* ennobling stories,
but in time they seemed less important than the visual skill
shown in depicting them. Thus the abstraction of artistic form

from any substantive content, which is part of the clichéd his-
tory of twentieth-century modernism, was already prepared by
the perspectival revolution five centuries earlier. What Bryson in
his book *Word and Image* calls the diminution of the discursive
function of painting, its telling a story to the unlettered masses,
in favor of its figural function,[16] meant the increasing autonomy
of the image from any extrinsic purpose, religious or otherwise.
The effect of realism was consequently enhanced as canvases
were filled with more and more information that seemed unre-
lated to any narrative or textual function. Cartesian perspectival-
ism was thus in league with a scientific world view that no
longer hermeneutically read the world as a divine text, but
rather saw it as situated in a mathematically regular spatio-tem-
poral order filled with natural objects that could only be ob-
served from without by the dispassionate eye of the neutral
researcher.

It was also complicitous, so many commentators have
claimed, with the fundamentally bourgeois ethic of the modern
world. According to Edgerton, Florentine businessmen with
their newly invented technique of double-entry bookkeeping may
have been "more and more disposed to a visual order that would
accord with the tidy principles of mathematical order that they
applied to their bank ledgers."[17] John Berger goes so far as to
claim that more appropriate than the Albertian metaphor of the
window on the world is that of "a safe let into a wall, a safe in
which the visible has been deposited."[18] It was, he contends, no
accident that the invention (or rediscovery) of perspective vir-
tually coincided with the emergence of the oil painting detached
from its context and available for buying and selling. Separate
from the painter and the viewer, the visual field depicted on the
other side of the canvas could become a portable commodity
able to enter the circulation of capitalist exchange. At the same
time, if philosophers like Martin Heidegger are correct, the nat-
ural world was transformed through the technological world

view into a "standing reserve" for the surveillance and manip-
ulation of a dominating subject.[19]

Cartesian perspectivalism has, in fact, been the target of a
widespread philosophical critique, which has denounced its priv-
ileging of an ahistorical, disinterested, disembodied subject en-
tirely outside of the world it claims to know only from afar. The
questionable assumption of a transcendental subjectivity charac-
teristic of universalist humanism, which ignores our embedded-
ness in what Maurice Merleau-Ponty liked to call the flesh of the
world, is thus tied to the "high altitude" thinking characteristic
of this scopic regime. In many accounts, this entire tradition has
thus been subjected to wholesale condemnation as both false and
pernicious.

Looked at more closely, however, it is possible to discern
internal tensions in Cartesian perspectivalism itself that suggest
it was not quite as uniformly coercive as is sometimes assumed.
Thus, for example, John White distinguishes between what he
terms "artificial perspective," in which the mirror held up to
nature is flat, and "synthetic perspective," in which that mirror
is presumed to be concave, thus producing a curved rather than
planar space on the canvas. Here, according to White, Paolo
Uccello and Leonardo da Vinci were the major innovators, offer-
ing a "spherical space which is homogeneous, but by no means
simple, and which possesses some of the qualities of Einstein's
finite infinity."[20] Although artificial perspective was the domi-
nant model, its competitor was never entirely forgotten.

Michael Kubovy has recently added the observation that
what he calls the "robustness of perspective"[21] meant that Ren-
aissance canvases could be successfully viewed from more than
the imagined apex of the beholder's visual pyramid. He criticizes
those who naively identify the rules of perspective established by
its theoretical champions with the actual practice of the artists
themselves. Rather than a procrustean bed, they were practically
subordinated to the exigencies of perception, which means that

denunciations of their failings are often directed at a straw man (or at least his straw eye).

Equally problematic is the subject position in the Cartesian perspectivalist epistemology. For the monocular eye at the apex of beholder's pyramid could be construed as transcendental and universal — that is, exactly the same for any human viewer occupying the same point in time and space — or contingent — solely dependent on the particular, individual vision of distinct beholders, with their own concrete relations to the scene in front of them. When the former was explicitly transformed into the latter, the relativistic implications of perspectivalism could be easily drawn. Even in the nineteenth century, this potential was apparent to thinkers like Leibniz, although he generally sought to escape its more troubling implications. These were not explicitly stressed and than praised until the late nineteenth century by such thinkers as Nietzsche. If everyone had his or her own camera obscura with a distinctly different peephole, he gleefully concluded, then no transcendental world view was possible.[22]

Finally, the Cartesian perspectivalist tradition contained a potential for internal contestation in the possible uncoupling of the painter's view of the scene from that of the presumed beholder. Interestingly, Bryson identifies this development with Vermeer, who represents for him a second state of perspectivalism even more disincarnated than that of Alberti. "The bond with the viewer's physique is broken and the viewing subject," he writes, "is now proposed and assumed as a notional point, a non-empirical Gaze."[23]

What makes this last observation so suggestive is the opening it provides for a consideration of an alternative scopic regime that may be understood as more than a subvariant of Cartesian perspectivalism. Although I cannot pretend to be a serious student of Vermeer able to quarrel with Bryson's interpretation of his work, it might be useful to situate the painter in a different

context from the one we have been discussing. That is, we might include him and the Dutch seventeenth-century art of which he was so great an exemplar in a visual culture very different from that we associate with Renaissance perspective, one which Svetlana Alpers has recently called *The Art of Describing*.[24]

According to Alpers, the hegemonic role of Italian painting in art history has occluded an appreciation of a second tradition, which flourished in the seventeenth-century Low Countries. Borrowing Georg Lukács's distinction between narration and description, which he used to contrast realist and naturalist fiction, she argues that Italian Renaissance art, for all its fascination with the techniques of perspective, still held fast to the storytelling function for which they were used. In the Renaissance, the world on the other side of Alberti's window, she writes, "was a stage in which human figures performed significant actions based on the texts of the poets. It is a narrative art."[25] Northern art, in contrast, suppresses narrative and textual reference in favor of description and visual surface. Rejecting the privileged, constitutive role of the monocular subject, it emphasizes instead the prior existence of a world of objects depicted on the flat canvas, a world indifferent to the beholder's position in front of it. This world, moreover, is not contained entirely within the frame of the Albertian window, but seems instead to extend beyond it. Frames do exist around Dutch pictures, but they are arbitrary and without the totalizing function they serve in Southern art. If there is a model for Dutch art, it is the map with its unapologetically flat surface and its willingness to include words as well as objects in its visual space. Summarizing the difference between the art of describing and Cartesian perspectivalism, Alpers posits the following oppositions:

attention to many small things versus a few large ones; light reflected off objects versus objects modeled by light and shadow; the surface of objects, their colors and textures, dealt with rather than their place-

ment in a legible space; an unframed image versus one that is clearly framed; one with no clearly situated viewer compared to one with such a viewer. The distinction follows a hierarchical model of distinguishing between phenomena commonly referred to as primary and secondary: objects and space versus the surfaces, forms versus the textures of the world.[26]

If there is a philosophical correlate to Northern art, it is not Cartesianism with its faith in a geometricalized, rationalized, essentially intellectual concept of space but rather the more empirical visual experience of observationally oriented Baconian empiricism. In the Dutch context Alpers identifies it with Constantin Huygens. The nonmathematical impulse of this tradition accords well with the indifference to hierarchy, proportion, and analogical resemblances characteristic of Cartesian perspectivalism. Instead, it casts its attentive eye on the fragmentary, detailed, and richly articulated surface of a world it is content to describe rather than explain. Like the microscopist of the seventeenth century — Leeuwenhoeck is her prime example — Dutch art savors the discrete particularity of visual experience and resists the temptation to allegorize or typologize what it sees, a temptation to which she claims Southern art readily succumbs.

In two significant ways, the art of describing can be said to have anticipated later visual models, however much it was subordinated to its Cartesian perspectivalist rival. As we have already noted, a direct filiation between Alberti's *velo* and the grids of modernist art is problematic because, as Rosalind Krauss has argued, the former assumed a three-dimensional world out there in nature, whereas the latter did not. A more likely predecessor can thus be located in the Dutch art based on the mapping impulse. As Alpers notes,

Although the grid that Ptolemy proposed, and those that Mercator later imposed, share the mathematical uniformity of the Renaissance perspective grid, they do not share the positioned viewer, the frame, and the

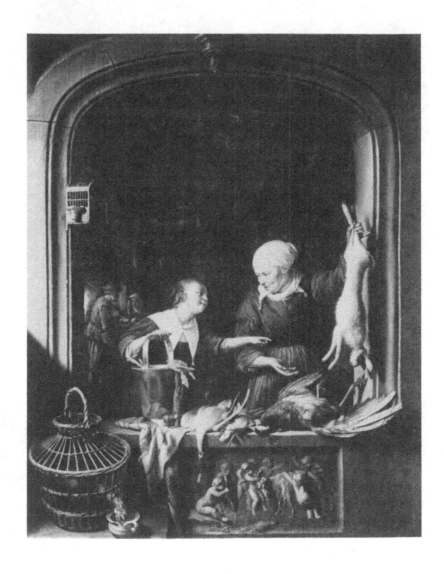

Gerrit Dou. *A Poulterer's Shop*, c. 1617. London, National Gallery of Art. (Courtesy of the Trustees, The National Gallery, London)

definition of the picture as a window through which an external viewer looks. On these accounts the Ptolemaic grid, indeed cartographic grids in general, must be distinguished from, not confused with, the perspectival grid. The projection is, one might say, viewed from nowhere. Nor is it to be looked through. It assumes a flat working surface.[27]

Secondly, the art of describing also anticipates the visual experience produced by the nineteenth-century invention of photography. Both share a number of salient features: "fragmentariness, arbitrary frames, the immediacy that the first practitioners expressed by claiming that the photograph gave Nature the power to reproduce herself directly unaided by man."[28] The parallel frequently drawn between photography and the anti-perspectivalism of impressionist art, made for example by Aaron Scharf in his discussion of Degas,[29] should thus be extended to include the Dutch art of the seventeenth century. And if Peter Galassi is correct in *Before Photography,* there was also a tradition of topographical painting—landscape sketches of a fragment of reality—that resisted Cartesian perspectivalism and thus prepared the way both for photography and the impressionist return to two-dimensional canvases.[30] How widespread or self-consciously oppositional such a tradition was I will leave to experts in art history to decide. What is important for our purposes is simply to register the existence of an alternative scopic regime even during the heyday of the dominant tradition.

Alpers's attempt to characterize it is, of course, open to possible criticisms. The strong opposition between narration and description she posits may seem less firm if we recall the de-narrativizing impulse in perspectival art itself mentioned above. And if we can detect a certain fit between the exchange principle of capitalism and the abstract relational space of perspective, we might also discern a complementary fit between the valorization of material surfaces in Dutch art and the fetishism of commodities no less characteristic of a market economy. In this

sense, both scopic regimes can be said to reveal different aspects of a complex but unified phenomenon, just as Cartesian and Baconian philosophies can be said to be consonant, if in different ways, with the scientific world view.

If, however, we turn to a third model of vision, or what can be called the second moment of unease in the dominant model, the possibilities for an even more radical alternative can be discerned. This third model is perhaps best identified with the baroque. At least as early as 1888 and Heinrich Wöfflin's epochal study, *Renaissance and Baroque,* art historians have been tempted to postulate a perennial oscillation between two styles in both painting and architecture.[31] In opposition to the lucid, linear, solid, fixed, planimetric, closed form of the Renaissance, or as Wölfflin later called it, the classical style, the baroque was painterly, recessional, soft-focused, multiple, and open. Derived, at least according to one standard etymology, from the Portuguese word for an irregular, oddly shaped pearl, the baroque connoted the bizarre and peculiar, traits which were normally disdained by champions of clarity and transparency of form.

Although it may be prudent to confine the baroque largely to the seventeenth century and link it with the Catholic Counter Reformation or the manipulation of popular culture by the newly ascendant absolutist state—as has, for example, the Spanish historian José Antonio Maravall[32]—it may also be possible to see it as a permanent, if often repressed, visual possibility throughout the entire modern era. In the recent work of the French philosopher Christine Buci-Glucksmann, *La raison baroque* of 1984 and *La folie du voir* of 1986,[33] it is precisely the explosive power of baroque vision that is seen as the most significant alternative to the hegemonic visual style we have called Cartesian perspectivalism. Celebrating the dazzling, disorienting, ecstatic surplus of images in baroque visual experience, she emphasizes its rejection of the monocular geometricalization of the Cartesian tradition, with its illusion of homogeneous three-dimen-

sional space seen with a God's-eye-view from afar. She also tacitly contrasts the Dutch art of describing, with its belief in legible surfaces and faith in the material solidity of the world its paintings map, with the baroque fascination for opacity, unreadability, and the indecipherability of the reality it depicts.

For Buci-Glucksmann, the baroque self-consciously revels in the contradictions between surface and depth, disparaging as a result any attempt to reduce the multiplicity of visual spaces into any one coherent essence. Significantly, the mirror that it holds up to nature is not the flat reflecting glass that commentators like Edgerton and White see as vital in the development of rationalized or "analytic" perspective, but rather the anamorphosistic mirror, either concave or convex, that distorts the visual image—or, more precisely, reveals the conventional rather than natural quality of "normal" specularity by showing its dependence on the materiality of the medium of reflection. In fact, because of its greater awareness of that materiality—what a recent commentator, Rodolphe Gasché, has drawn attention to as the "tain of the mirror"[34]—baroque visual experience has a strongly tactile or haptic quality, which prevents it from turning into the absolute ocularcentrism of its Cartesian perspectivalist rival.

In philosophical terms, although no one system can be seen as its correlate, Leibniz's pluralism of monadic viewpoints,[35] Pascal's meditations on paradox, and the Counter Reformation mystics' submission to vertiginous experiences of rapture might all be seen as related to baroque vision. Moreover, the philosophy it favored self-consciously eschewed the model of intellectual clarity expressed in a literal language purified of ambiguity. Instead, it recognized the inextricability of rhetoric and vision, which meant that images were signs and that concepts always contained an irreducibly imagistic component.

Baroque vision, Buci-Glucksmann also suggests, sought to represent the unrepresentable and, necessarily failing, produced the melancholy that Walter Benjamin in particular saw as

characteristic of the baroque sensibility. As such, it was closer to what a long tradition of aesthetics called the sublime, in contrast to the beautiful, because of its yearning for a presence that can never be fulfilled. Indeed, desire, in its erotic as well as metaphysical forms, courses through the baroque scopic regime. The body returns to dethrone the disinterested gaze of the disincarnated Cartesian spectator. But unlike the return of the body celebrated in such twentieth-century philosophies of vision as Merleau-Ponty's, with its dream of meaning-laden imbrication of the viewer and the viewed in the flesh of the world, here it generates only allegories of obscurity and opacity. Thus it truly produces one of those "moments of unease" which Jacqueline Rose sees challenging the petrification of the dominant visual order (the art of describing seeming in fact far more at ease in the world).

A great deal more might be said about these three ideal typical visual cultures, but let me conclude by offering a few speculations, if I can use so visual a term, on their current status. First, it seems undeniable that we have witnessed in the twentieth century a remarkable challenge to the hierarchical order of the three regimes. Although it would be foolish to claim that Cartesian perspectivalism has been driven from the field, the extent to which it has been denaturalized and vigorously contested, in philosophy as well as in the visual arts, is truly remarkable. The rise of hermeneutics, the return of pragmatism, the profusion of linguistically oriented structuralist and poststructuralist modes of thought have all put the epistemological tradition derived largely from Descartes very much on the defensive. And, of course, the alternative of Baconian observation, which periodically resurfaces in variants of positivistic thought, has been no less vulnerable to attack, although one might argue that the visual practice with which it had an elective affinity has shown remarkable resilience with the growing status of photography as a nonperspectival art form (or, if you

prefer, counter-art form). There are as well contemporary artists like the German Jewish, now Israeli painter Joshua Neustein, whose fascination with the flat materiality of maps has recently earned a comparison with Alpers's seventeenth-century Dutchmen.[36]

Still, if one had to single out the scopic regime that has finally come into its own in our time, it would be the "madness of vision" Buci-Glucksmann identifies with the baroque. Even photography, if Rosalind Krauss's recent work on the Surrealists is any indication,[37] can lend itself to purposes more in line with this visual impulse than the art of mere describing. In the postmodern discourse that elevates the sublime to a position of superiority over the beautiful, it is surely the "palimpsests of the unseeable,"[38] as Buci-Glucksmann calls baroque vision, that seem most compelling. And if we add the current imperative to restore rhetoric to its rightful place and accept the irreducible linguistic moment in vision and the equally insistent visual moment in language, the timeliness of the baroque alternative once again seems obvious.

In fact, if I may conclude on a somewhat perverse note, the radical dethroning of Cartesian perspectivalism may have gone a bit too far. In our haste to denaturalize it and debunk its claims to represent vision per se, we may be tempted to forget that the other scopic regimes I have quickly sketched are themselves no more natural or closer to a "true" vision. Glancing is not somehow innately superior to gazing; vision hostage to desire is not necessarily always better than casting a cold eye; a sight from the situated context of a body in the world may not always see things that are visible to a "high-altitude" or "God's-eye-view." However we may regret the excesses of scientism, the Western scientific tradition may have only been made possible by Cartesian perspectivalism or its complement, the Baconian art of describing. There may well have been some link between the absence of such scopic regimes in Eastern cultures, especially the

former, and their general lack of indigenous scientific revolutions. In our scramble to scrap the rationalization of sight as a pernicious reification of visual fluidity, we need to ask what the costs of too uncritical an embrace of its alternatives may be. In the case of the art of describing, we might see another reification at work, that which makes a fetish of the material surface instead of the three-dimensional depths. Lukács's critique of naturalist description in literature, unmentioned by Alpers, might be applied to painting as well. In the case of baroque vision, we might wonder about the celebration of ocular madness, which may produce ecstasy in some, but bewilderment and confusion in others. As historians like Maravall have darkly warned, the phantasmagoria of baroque spectacle was easily used to manipulate those who were subjected to it. The current vision of "the culture industry," to use the term Maravall borrows from Horkheimer and Adorno in his account of the seventeenth century, does not seem very threatened by postmodernist visual experiments in "la folie du voir." In fact, the opposite may well be the case.

Rather than erect another hierarchy, it may therefore be more useful to acknowledge the plurality of scopic regimes now available to us. Rather than demonize one or another, it may be less dangerous to explore the implications, both positive and negative, of each. In so doing, we won't lose entirely the sense of unease that has so long haunted the visual culture of the West, but we may learn to see the virtues of differentiated ocular experiences. We may learn to wean ourselves from the fiction of a "true" vision and revel instead in the possibilities opened up by the scopic regimes we have already invented and the ones, now so hard to envision, that are doubtless to come.

Notes

1. See, for example, Lucien Febvre, *The Problem of Unbelief in the Sixteenth Century: The Religion of Rabelais,* trans. Beatrice Gottlieb (Cambridge, Mass.: Harvard University Press, 1982) and Robert Mandrou, *Introduction to Modern France, 1500-1640: An Essay in Historical Psychology,* trans. R. E. Hallmark (New York: Holmes & Meier, 1975).

2. Marshall McLuhan, *Understanding Media: The Extensions of Man* (New York: McGraw-Hill, 1964); Walter J. Ong, *The Presence of the Word: Some Prolegomena for Cultural and Religious History* (New Haven: Yale University Press, 1967); see also Elizabeth L. Eisenstein, *The Printing Press as an Agent of Change: Communications and Cultural Transformations in Early Modern Europe,* 2 vols. (Cambridge: Cambridge University Press, 1979).

3. Donald M. Lowe, *History of Bourgeois Perception* (Chicago: University of Chicago Press, 1982), p. 26.

4. For an account of the positive attitude towards vision in the medieval church, see Margaret R. Miles, *Image as Insight: Visual Understanding in Western Christianity and Secular Culture* (Boston: Beacon Press, 1985). Contrary to the argument of Febvre and Mandrou, which has been very influential, she shows the extent to which sight was by no means widely demeaned in the Middle Ages.

5. Richard Rorty, *Philosophy and the Mirror of Nature* (Princeton: Princeton University Press, 1979); Michel Foucault, *Discipline and Punish: The Birth of the Prison,* trans. Alan Sheridan (New York: Vintage Books, 1979); Guy Debord, *Society of the Spectacle,* rev. ed. (Detroit: Black and Red, 1977).

6. Christian Metz, *The Imaginary Signifier: Psychoanalysis and the Cinema,* trans. Celia Britton et al. (Bloomington: Indiana University Press, 1982), p. 61.

7. Jacqueline Rose, *Sexuality in the Field of Vision* (London: Verso, 1986), pp. 232-233.

8. William M. Ivins, Jr., *Art and Geometry: A Study in Space Intuitions* (Cambridge, Mass.: Harvard University Press, 1946), p. 81.

9. Rorty, p. 45.

10. Erwin Panofsky, "Die Perspektive als 'symbolischen Form,'" *Vorträge der Bibliothek Warburg* 4 (1924-1925): 258-331.

11. William M. Ivins, Jr., *On the Rationalization of Sight* (New York: Metropolitan Museum of Art, 1938); Panofsky, "Die Perspektive als 'symbolischen Form'"; Richard Krautheimer, "Brunelleschi and Linear Perspective," in *Brunelleschi in Perspective,* comp. Isabelle Hyman (Englewood Cliffs, N.J.: Prentice-Hall, 1974); Samuel Y. Edgerton, Jr., *The Renaissance Discovery of Linear Perspective* (New York: Basic Books, 1975); John White, *The Birth and Rebirth of Pictorial Space,* 3rd ed. (Cambridge, Mass.: Belknap Press, 1987); Michael Kubovy, *The Psychology of Perspective and Renaissance Art* (Cambridge: Cambridge University Press, 1986).

12. Rosalind E. Krauss, *The Originality of the Avant-Garde and Other Modernist Myths* (Cambridge, Mass.: The MIT Press, 1985), p. 10.

13. Norman Bryson, *Vision and Painting: The Logic of the Gaze* (New Haven: Yale University Press, 1983), p. 94.

14. Augustine discusses ocular desire in Chapter 35 of the *Confessions*.

15. For a discussion of the gender implications of this work, see Svetlana Alpers, "Art History and its Exclusions," in *Feminism and Art History: Questioning the Litany*, ed. Norma Broude and Mary D. Garrard (New York: Harper and Row, 1982), p. 187.

16. Norman Bryson, *Word and Image: French Painting of the Ancien Régime* (Cambridge: Cambridge University Press, 1981), chapter I.

17. Edgerton, p. 39.

18. John Berger, *Ways of Seeing* (London: BBC, 1972), p. 109.

19. Martin Heidegger, "The Question Concerning Technology," in *The Question Concerning Technology, and Other Essays*, trans. William Lovitt (New York: Harper and Row, 1977). Heidegger's most extensive critique of Cartesian perspectivalism can be found in his essay "The Age of the World Picture," in the same volume.

20. White, p. 208.

21. Kubovy, chapter IV.

22. Sarah Kofman, *Camera Obscura, de l'idéologie* (Paris: Éditions Galilée, 1973), treats this theme in Nietzsche.

23. Bryson, *Vision and Painting*, p. 112.

24. Svetlana Alpers, *The Art of Describing: Dutch Art in the Seventeenth Century* (Chicago: University of Chicago Press, 1983).

25. Ibid., p. xix.

26. Ibid., p. 44.

27. Ibid., p. 138.

28. Ibid., p. 43.

29. Aaron Scharf, *Art and Photography* (London: Allen Lane, 1968; reprint, New York: Penguin Books, 1986), chapter VIII.

30. Peter Galassi, *Before Photography: Painting and the Invention of Photography* (New York: Museum of Modern Art, 1981).

31. Heinrich Wölfflin, *Renaissance and Baroque*, trans. Kathrin Simon (Ithaca, N.Y.: Cornell University Press, 1966). See also the systematic development of the contrast in *Principles of Art History: The Problem of the Development of Style in Later Art*, trans. M. D. Hottinger (London: G. Bell & Sons, Ltd., 1932).

32. José Antonio Maravall, *Culture of the Baroque: Analysis of a Historical Structure*, trans. Terry Cochran (Minneapolis: University of Minnesota Press, 1986).

33. Christine Buci-Glucksmann, *La raison baroque: de Baudelaire à Benjamin* (Paris:

Éditions Galilée, 1984) and *La folie du voir: de l'esthétique baroque* (Paris: Éditions Galilée, 1986).

34. Rodolphe Gasché, *The Tain of the Mirror: Derrida and the Philosophy of Reflection* (Cambridge, Mass.: Harvard University Press, 1986).

35. As Buci-Glucksmann recognizes, Leibnizian pluralism retains a faith in the harmonizing of perspectives that is absent from the more radically Nietzschean impulse in the baroque. See *La folie du voir*, p. 80, where she identifies that impulse with Gracián and Pascal.

36. See Irit Rogoff, "Mapping Out Strategies of Dislocation," in the catalogue for Neustein's October 24–November 26, 1987 show at the Exit Art gallery in New York.

37. Krauss, "The Photographic Conditions of Surrealism," in *The Originality of the Avant-Garde*. See also her work with Jane Livingston, *L'amour fou: Photography and Surrealism* (New York: Abbeville Press, 1985).

38. Buci-Glucksmann, *La folie du voir*, chapter VI.

Jacqueline Rose I want to ask a question about your idea of "the plurality of scopic regimes." I take your point that this spectacular plurality can be used as an oppressive device. But the critique of Cartesian perspective has always been tied to a specific conception of the political and to a particular notion of the bourgeois subject. And I wonder what happens to that political critique if one reformulates it as you have.

Martin Jay It would be fascinating to map out the political implications of scopic regimes, but it can't be done too reductively. The perspectivalist regime is not necessarily complicitous only with politically oppressive practices. Under certain circumstances it may be emancipatory; it really depends on how it is used. And the same is arguable about any alternatives that are presented.

 The perspectivalist regime may be complicitous with a certain notion of an isolated bourgeois subject, a subject that fails to recognize its corporeality, its intersubjectivity, its embeddedness in the flesh of the world. Of course, this subject is now very much under attack, and I don't want to reconstitute it naively. Nevertheless, Cartesian perspectivalism also functions in the service of types of political self-understanding that depend on distanciation—explanatory social-scientific models, for example, which argue against the hermeneutic immersion of the self in the world and create at least the fiction of an objective distance from it. Here I think of the combination that Jürgen Habermas has introduced in his discussion of the logic of the social sciences—a combination of explanatory and hermeneutic understanding based largely on a perspectivalist fiction of being outside the object of inquiry. This fiction is easy to debunk because we are always embedded in the world; it is also easy to

criticize its relation to scientism. But before we move too quickly to a counterscientific position, we should recognize that Western science depended on this practically useful fiction of a distanciating vision. I don't want in any way to underplay the dangers here—gender dangers, class dangers, and so forth. Nonetheless, one can sometimes disentangle the political from the visual; it is not always entailed.

Norman Bryson I have a question about Dutch art, your second scopic regime. It's true that, unlike Mediterranean art, Dutch art does seem typically to get rid of the frame: the framing of the image seems arbitrary—a random cut—and composition doesn't appear as the set of repercussions within the image of its frame. Nevertheless, one could also say that Dutch art is, so to speak, hyperreal compared to Mediterranean art: it is even more realist precisely because it is not limited by structures of the frame. And although Northern painting follows another perspectival system—spherical rather than flat—its commitment to perspective is not fundamentally different from that in the south. In short, I wonder whether there really is such a difference between Dutch art and Mediterranean art, and whether a real point of difference between Cartesian perspectivalism and other modes has to do instead with the performative—the idea of performance and the insertion of embodiment into the optical field. I am thinking here of baroque art, but also of nineteenth-century art forms in which there is a considerable intervention of the bodily into the frame—in the visibility of pigment and gesture, in the rise of the sketch, and in bravura styles such as that of Delacroix or of Daumier. The significant break with Cartesian perspectivalism might be found in this fracturing of visual space upon the entry of the body.

Jay In a way I was trying to make the same point: that Dutch art is not as radical a break with perspectivalism as baroque art.

But here I should clarify what I mean by realism. One might, as Svetlana Alpers does, draw on the familiar Lukácsian distinction between realism and naturalism (which should be taken with a grain of salt). As Lukács describes it, realism deals with typological, essential depths—not with surfaces. Narration produces a typological sense of meaningfulness which goes beyond the scattered and untotalizable facts of a literary text (or perhaps a painting). With its stress on the three-dimensional space rather than the two-dimensional surface of the canvas, Cartesian perspectivalism is realist in this sense. Naturalism, on the other hand, is interested solely in surface—in describing its varieties of forms without reducing them to any symbolically meaningful visual depth. It rests content with the visual experience of light on our eyes.

Now these modes of realism and naturalism might well be seen as complementary. Both create a reality-effect, the one by our belief that reality is depth, the other by simply showing surfaces. Both modes are also complicitous with a certain kind of scientific thought; indeed, science has gone back and forth between such Cartesian and Baconian notions of where reality lies. But I think you are right: the third alternative calls both of them into question through a performative critique of the reality-effect itself. In painting I suppose this is produced by the painter or the beholder entering the picture in some metaphorical way; this makes it impossible to see the painting as a scene out there viewed with either the realist or the naturalist eye. It would be interesting to see what the history of that more radical alternative might be. Certainly, as I argued at the end of my paper, it seems to entrance many of us now.

Hal Foster Could you say a little more about how, in your way of thinking, Cartesian perspectivalism de-eroticizes?

Jay The argument is that perspectivalism creates such a distance

between the disincarnated eye and the depicted scene that the painting lacks the immediacy associated with desire. But this is often called into question by various aesthetic practices; I mentioned Caravaggio as an example. One crucial thing here is the crossing of gazes; in most nudes the figure does not look back at us, but rather is objectified in such a way that our gaze meets no intersubjective return look. In Manet, however, there is such a *frisson* of reciprocity, which was lost in the Cartesian perspectivalist construction, and the result was de-eroticization.

Foster In your model, then, de-eroticization is somehow opposed to fetishization?

Jay That's an interesting issue. A fetish can be seen as erotic, or as producing a kind of closed entity which lacks erotic reciprocity. Maybe there are two types of erotic relationship, the one fetishistic, the other not. Certainly fetishism occurs more in Dutch art in terms of the objects on the canvas. If there is a fetishism in Cartesian perspectivalism, it is a fetishism of the space itself. But it would be interesting to pursue an idea of different modes of erotic interaction rather than the simple opposition of the erotic versus the de-eroticized.

Jonathan Crary

MODERNIZING VISION

My starting point is the various ways in which vision and the techniques and discourses surrounding it have been periodized historically. It is interesting that so many attempts to theorize vision and visuality are wedded to models that emphasize a continuous and overarching Western visual tradition. Obviously at times it is strategically necessary to map out and pose the outlines of a dominant Western speculative or scopic tradition of vision that is continuous or in some sense effective, for instance, from Plato to the present, or from the Quattrocento into the twentieth century, or to whenever. My concern is not so much to argue against these models, which have their own usefulness, but rather to insist there are some important discontinuities that such hegemonic constructions have prevented from coming into view. The specific account that interests me here, one that has become almost ubiquitous and continues to be developed in a variety of forms, is that the emergence of photography and cinema in the nineteenth century is a fulfillment of a long unfolding of technological and/or ideological development in the West in which the camera obscura evolves into the photographic camera. Implied is that at each step in this evolution the same essential presuppositions about an observer's relation to the world are in place. One could name a dozen or more books on the history of film or photography in whose first chapter appears the obligatory seventeenth-century engraving depicting a camera obscura, as a kind of inaugural or incipient form on a long evolutionary ladder.

These models of continuity are used in the service of both,

for lack of better terms, the right and the left. On the one hand are those who pose an account of ever-increasing progress toward verisimilitude in representation, in which Renaissance perspective and photography are part of the same quest for a fully objective equivalent of "natural vision." On the other are those who see, for example, the camera obscura and cinema as bound up in a single enduring apparatus of power, elaborated over several centuries, that continues to define and regulate the status of an observer.

What I want to do are essentially two related things: (1) to briefly and very generally articulate the camera obscura model of vision in terms of its historical specificity, and (2) to suggest how that model collapsed in the early nineteenth century—in the 1820s and 1830s—when it was displaced by radically different notions of what an observer was and of what constituted vision. So if later in the nineteenth century cinema or photography seem to invite formal comparisons with the camera obscura, or if Marx, Freud, Bergson, and others refer to it, it is within a social, cultural, and scientific milieu in which there had already been a profound rupture with the conditions of vision presupposed by this device.

For at least two thousand years it has been known that, when light passes through a small hole into a dark, enclosed interior, an inverted image will appear on the wall opposite the hole. Thinkers as remote from each other as Euclid, Aristotle, Roger Bacon, and Leonardo noted this phenomenon and speculated in various ways how it might or might not be analogous to the functioning of human vision.

But it is crucial to make a distinction between the empirical fact that an image can be produced in this way (something that continues to be as true now as it was in antiquity) and the camera obscura as a socially constructed artifact. For the camera obscura was not simply an inert and neutral piece of equipment

or a set of technical premises to be tinkered upon and improved over the years; rather, it was embedded in a much larger and denser organization of knowledge and of the observing subject. If we want to be historical about it, we must recognize how for nearly two hundred years, from the late 1500s to the end of the 1700s, the structural and optical principles of the camera obscura coalesced into a dominant paradigm through which was described the status and possibilities of an observer.

It became a model, obviously elaborated in a variety of ways, for how observation leads to truthful inferences about an external world. It was an era when the camera obscura was simultaneously and inseparably a central epistemological figure within a discursive order, as in Descartes's *Dioptrics,* Locke's *Essay on Human Understanding,* and Leibniz's critique of Locke, *and* occupied a major position within an arrangement of technical and cultural practices, for example in the work of Kepler and Newton. As a complex technique of power, it was a means of legislating for an observer what constituted perceptual "truth," and it delineated a fixed set of relations to which an observer was made subject.

What I will argue is that very early on in the nineteenth century the camera obscura collapses as a model for an observer and for the functioning of human vision. There is a profound shift in the way in which an observer is described, figured, and posited in science, philosophy, and in new techniques and practices of vision. Here I want briefly and very sketchily to indicate a few important features of this shift.

First, a bit more about the camera obscura in the seventeenth and eighteenth centuries. Above all, whether in the work of scientists or artists, empiricists or rationalists, it was an apparatus that guaranteed access to an objective truth about the world. It assumed importance as a model both for the observation of empirical phenomenon and for reflective introspection and self-observation. In Locke, for example, the camera is a

means of spatially visualizing the position of an observing subject.[1] The image of the room in Locke takes on a special significance, referring to what it meant in the seventeenth century to be *in camera,* that is, within the chambers of a judge or person of title.[2] Thus he adds onto the observer's passive role a more authoritative and juridical function to guarantee and to police the correspondence between exterior world and interior representation and to exclude anything disorderly or unruly.

Richard Rorty has pointed to Locke and Descartes as key figures in establishing this conception of the human mind as "an inner space in which clear and distinct ideas passed in review before an inner Eye . . . an inner space in which perceptual sensations were themselves the objects of quasi-observation."[3] For Descartes, the camera obscura was a demonstration of how an observer can know the world "uniquely by perception of the mind." The secure positioning of the self with this empty interior space was a precondition for knowing the outer world. Its enclosedness, its darkness, its categorical separation from an exterior incarnates Descartes's announcement in the Third Meditation, "I will now shut my eyes, I shall stop my ears, I shall disregard my senses."[4] If part of Descartes's method implied a need to escape the uncertainties of mere human vision, the camera obscura is compatible with his quest to found knowledge on a purely objective view of the world. The aperture of the camera corresponds to a single mathematically definable point from which the world could be logically deduced and re-presented. Founded on laws of nature—that is, geometrical optics—the camera provided an infallible vantage point on the world. Sensory evidence that depended in any way on the body was rejected in favor of the representations of this mechanical and monocular apparatus, whose authenticity was placed beyond doubt.

Monocular, not binocular. A single eye, not two. Until the nineteenth century, binocular disparity, the fact that we see a

slightly different image with each eye, was never seriously addressed as a central issue. It was ignored or minimized as a problem, for it implied the inadmissible physiological and anatomical operation of human vision. A monocular model, on the other hand, precluded the difficult problem of having to reconcile the dissimilar and therefore provisional and tentative images presented to each eye. Monocularity, like perspective and geometrical optics, was one of the Renaissance codes through which a visual world is constructed according to systematized constants, and from which any inconsistencies and irregularities are banished to insure the formation of a homogeneous, unified, and fully legible space.

Finally to wind up this extremely compressed outline, it should also be suggested how closely the camera obscura is bound up with a metaphysic of interiority. It is a figure for the observer who is nominally a free sovereign individual but who is also a privatized isolated subject enclosed in a quasi-domestic space separated from a public exterior world. It defined an observer who was subjected to an inflexible set of positions and divisions. The visual world could be appropriated by an autonomous subject but only as a private unitary consciousness detached from any active relation with an exterior. The monadic viewpoint of the individual is legitimized by the camera obscura, but his or her sensory experience is subordinated to an external and pre-given world of objective truth.

What is striking is the suddenness and thoroughness with which this paradigm collapses in the early nineteenth century and gives way to a diverse set of fundamentally different models of human vision. I want to discuss one crucial dimension of this shift, the insertion of a new term into discourses and practices of vision: the human body, a term whose exclusion was one of the foundations of classical theories of vision and optics as I have just suggested. One of the most telling signs of the new centrality of the

body in vision is Goethe's *Theory of Colours,* published in 1810, which I have discussed at length elsewhere.[5] This is a work crucial not for its polemic with Newton over the composition of light but for its articulation of a model of subjective vision in which the body is introduced in all its physiological density as the ground on which vision is possible. In Goethe we find an image of a newly productive observer whose body has a range of capacities to generate visual experience; it is a question of visual experience that does not refer or correspond to anything external to the observing subject. Goethe is concerned mainly with the experiences associated with the retinal afterimage and its chromatic transformations. But he is only the first of many researchers who become preoccupied with the afterimage in the 1820s and 1830s throughout Europe. Their collective study defined how vision was an irreducible amalgam of physiological processes and external stimulation, and dramatized the productive role played by the body in vision.

Although we are talking about scientists, what is in question here is the discovery of the "visionary" capacities of the body, and we miss the significance of this research if we don't recall some of its strange intensity and exhilaration. For what was often involved was the experience of staring directly into the sun, of sunlight searing itself onto the body, palpably disturbing it into a proliferation of incandescent color. Three of the most celebrated students of vision of this period went blind or permanently damaged their eyesight by repeatedly staring at the sun: David Brewster, who invented the kaleidoscope and stereoscope; Joseph Plateau, who studied the so-called persistence of vision; and Gustav Fechner, one of the founders of modern quantitative psychology. Fechner's biography provides an account of the almost addictive fascination with which he persisted in this activity. At the same time in the late 1830s and early 1840s we have the visual expression of these attempts in the late paintings of Turner, in which there is that piercing confrontation of

eye and sun, paintings in which the strictures that previously had mediated and regulated vision are abandoned. Nothing now protects or distances the observer from the seductive and sensual brilliance of the sun. The symbolic confines of the camera obscura have crumbled.

Obviously afterimages have been noted and recorded since antiquity, but they had always been outside or on the margins of the domain of optics. They were considered illusions — deceptive, spectral, and unreal. In the early nineteenth century such experiences that previously had been an expression of the frailty and the unreliability of the body now constituted the positivity of vision. But perhaps more importantly, the privileging of the body as a visual producer began to collapse the distinction between inner and outer upon which the camera obscura depended. Once the objects of vision are coextensive with one's own body, vision becomes dislocated and depositioned onto a single immanent plane. The bipolar setup vanishes. Thirdly, subjective vision is found to be distinctly temporal, an unfolding of processes within the body, thus undoing notions of a direct correspondence between perception and object. By the 1820s, then, we effectively have a model of autonomous vision.

The subjective vision that endowed the observer with a new perceptual autonomy and productivity was simultaneously the result of the observer having been made into a subject of new knowledge, of new techniques of power. And the terrain on which these two interrelated observers emerged in the nineteenth century was the science of physiology. From 1820 through the 1840s it was very unlike the specialized science that it later became; it had then no formal institutional identity and came into being as the accumulated work of disconnected individuals from diverse branches of learning. In common was the excitement and wonderment at the body, which now appeared like a new continent to be mapped, explored, and mastered, with new re-

cesses and mechanisms uncovered for the first time. But the real
importance of physiology lay in the fact that it became the arena
for new types of epistemological reflection that depended on
new knowledge about the eye and processes of vision. Physiology
at this moment of the nineteenth century is one of those sci-
ences that stand for the rupture that Foucault poses between the
eighteenth and nineteenth centuries, in which man emerges as a
being in whom the transcendent is mapped onto the empirical.[6]
It was the discovery that knowledge was conditioned by the
physical and anatomical structure and functioning of the body,
and in particular of the eyes. At the same time, as Georges Can-
guilhem has noted, for the new sciences in the nineteenth cen-
tury the body was *a priori* a productive body: it existed to be set
to work.[7]

Even in the early 1820s the study of afterimages quickly
became the object of a more rigorous and *quantitative* scientific
research throughout Europe. Studied was the persistence and
modulation of afterimages: how long they lasted, what changes
they went through, and under what conditions. But instead of
recording afterimages in terms of the lived time of the body as
Goethe had generally done, they were studied as part of a com-
prehensive quantification of the irritability of the eye. Re-
searchers timed how long it took the eye to become fatigued,
how long dilation and contraction of the pupil took, and mea-
sured the strength of eye movements. They examined con-
vergence and accommodation in binocular vision and the
relation of image to retinal curvature.

The physical surface of the eye itself became a field of sta-
tistical information: the retina was demarcated in terms of how
color changes hue depending on where it strikes the eye. Also
measured were the extent of the area of visibility, of peripheral
vision, the distinction between direct and indirect vision, and
the location of the blind spot. Classical optics, which had stud-
ied the transparency of mechanical optical systems, gave way to

a mapping of the human eye as an opaque territory with varying zones of efficiency and aptitude and specific parameters of normal and pathological vision. Some of the most celebrated of these experiments were Joseph Plateau's calculation, in the 1830s, of the average duration of an afterimage, or persistence of vision, which was about one-third of a second, and later, Helmholtz's measurement of the speed of nerve transmission, which astounded people by how slow it was, about ninety feet per second. Both statistics heightened the sense of a temporal disjunction between perception and its object *and* suggested new possibilities of intervening externally in the process of vision.

Clearly this study of the eye in terms of reaction time and thresholds of fatigue and stimulation was not unrelated to increasing demand for knowledge about the adaptation of a human subject to productive tasks in which optimum attention span was indispensable for the rationalization of human labor. The economic need for rapid coordination of hand and eye in performing repetitive actions required accurate knowledge of human optical and sensory capacities. In the context of new industrial models of factory production the problem of visual inattention was a serious one. But what developed was a notion of vision that was fundamentally quantitative, in which the terms constituting the relation between perception and object became abstract, interchangeable, and nonvisual. One of the most paradoxical figures of the nineteenth century is Gustav Fechner, whose delirious and even mystical experiences with solar afterimages led to his mathematization of perception, in which he established a functional relation between stimulus and sensation.[8] Sensory perception was given a measurable magnitude solely in terms of the known and controllable magnitudes of external stimulation. Vision became studied in terms of abstract measurable regularities, and Fechner's famous equations were to be one of the foundations of modern stimulus-response psychology.

Another dimension of the collective achievement of phys-

iology in the first half of the nineteenth century was the gradual parcelization and division of the body into increasingly separate and specific systems and functions. Especially important were the localization of brain and nerve functions, and the distinction between sensory nerves and motor nerves. Finally, by 1826 it was determined that sensory nerves were of five distinct types, corresponding to the five senses. All of this produced a new "truth" about the body which some have linked to the so-called "separation of the senses" in the nineteenth century, and to the idea that the specialization of labor was homologous to a specialization of sight and of a heightened autonomous vision, something that Fredric Jameson develops briefly but provocatively in *The Political Unconscious.*[9] I believe, however, that such a homology doesn't take account of how thoroughly vision was reconceived in the earlier nineteenth century. It still seems to pose observation as the act of a unified subject looking out onto a world that is the object of his or her sight, only that, because the objects of the world have become reified and commodified, vision in a sense becomes conscious of itself as sheer looking.

But in the first major scientific theorization of the separation of the senses, there is a much more decisive break with the classical observer; and what is at stake is not simply the heightening or isolating of the optical but rather a notion of an observer for whom vision is conceived without any necessary connection to the act of looking at all. The work in question is the research of the German physiologist Johannes Müller, the single most important theorist of vision in the first half of the nineteenth century.[10] In his study of the physiology of the senses, Müller makes a comprehensive statement on the subdivision and specialization of the human sensory apparatus; his fame was due to his theorization of that specialization: the so-called "doctrine of specific nerve energies." It was a theory in many ways as important to the nineteenth century as the Molyneux problem was to the eighteenth century. It was the foundation of

Helmholtz's *Optics,* which dominated the second half of the
1800s; in science, philosophy, and psychology it was widely pro-
pounded, debated, and denounced even into the early twentieth
century. (Also, I believe Marx was paraphrasing this work when
he discussed the separation of the senses in his *1844 Manu-
scripts.*[11]) In short, this is a major way in which an observer was
figured in the nineteenth century, a way in which a certain
"truth" about sight was depicted.

The theory was based on the discovery that the nerves of
the different senses were physiologically distinct. It asserted
quite simply—and this is what marks its epistemological scan-
dal—that a uniform cause (e.g., electricity) would generate
utterly different sensations from one kind of nerve to another.
Electricity applied to the optic nerve produces the experience of
light, applied to the skin the sensation of touch. Conversely,
Müller shows that a variety of different causes will produce the
same sensation in a given sensory nerve; in other words, he de-
scribes a fundamentally arbitrary relation between stimulus and
sensation. It is a description of a body with an innate capacity,
one might even say a transcendental faculty, to *misperceive,* of an
eye that renders differences equivalent.

His most exhaustive demonstration concerns the sense of
sight, and he concludes that the observer's experience of light
has no necessary connection with any actual light. Müller enu-
merates the agencies capable of producing the sensation of light.
"The sensations of light and color are produced wherever parts
of the retina are excited 1) by mechanical influences, such as
pressure, a blow or concussion 2) by electricity 3) by chemical
agents, such as narcotics, digitalis 4) by the stimulus of the blood
in a state of congestion."[12] Then last on his list, almost be-
grudgingly, he adds that luminous images also can be produced
by "the undulations and emanation which by their action on the
eye are called light."

Again the camera obscura model is made irrelevant. The

experience of light becomes severed from any stable point of reference or from any source or origin around which a world could be constituted and apprehended. And of course the very independent identity of light had already been undermined as a new wave theory of light became part of a science of electro-magnetic phenomena.

Sight here has been separated and specialized certainly, but it no longer resembles any classical models. The theory of specific nerve energies presents the outlines of a visual modernity in which the "referential illusion" is unsparingly laid bare. The very absence of referentiality is the ground on which new instrumental techniques will construct for an observer a new "real" world. It is a question of a perceiver whose very empirical nature renders identities unstable and mobile, and for whom sensations are interchangeable. And remember, this is roughly 1830. In effect, the doctrine of specific nerve energies redefines vision as a capacity for being affected by sensations that have no necessary link to a referent, thus threatening any coherent system of meaning. Müller's theory was potentially so nihilistic that it is no wonder that Helmholtz and others, who accepted its empirical premises, were impelled to invent theories of cognition and signification which concealed its uncompromising cultural implications. But what was at stake and seemed so threatening was not just a new form of epistemological skepticism about the unreliability of the senses but a positive reorganization of perception and its objects. The issue was not just how does one know what is real, but that new forms of the real were being fabricated and a new truth about the capacities of a human subject was being articulated in these terms.

The theory of specific nerve energies eradicated distinctions between internal and external sensation, so that interiority was drained of the meanings it once had for a classical observer, or

for the model of the camera obscura. In his supposedly empirical description of the human sensory apparatus, Müller presents the subject not as a unitary "tabula rasa," but as a composite structure on which a wide range of techniques and forces could produce a manifold of experiences that are all equally "reality." If John Ruskin proposed reclaiming the "innocence of the eye," this was about as innocent as one could get. The observer is simultaneously the object of knowledge and the object of procedures of stimulation and normalization, which have the essential capacity *to produce experience for the subject*. Ironically the notions of the reflex arc and reflex action, which in the seventeenth century referred to vision and the optics of reflection, begin to become the centerpiece of an emerging technology of the subject, culminating in the work of Pavlov.

In his account of the relation between stimulus and sensation, Müller suggests not an orderly and legislative functioning of the senses, but rather their receptivity to calculated management and derangement. Émile Dubois-Reymond, a colleague of Helmholtz, seriously pursued the possibility of electrically cross-connecting nerves, enabling the eye to see sounds and the ear to hear colors, well before Rimbaud. It must be emphasized that Müller's research and that of psychophysics in the nineteenth century is inseparable from the resources made available by contemporary work in electricity and chemistry. Some of the empirical evidence by Müller had been available since antiquity, or was in the domain of common-sense knowledge. However, what is new is the extraordinary privilege given to a complex of electro-physical techniques. What constitutes "sensation" is dramatically expanded and transformed, and it has little in common with how it was discussed in the eighteenth century. The adjacency of Müller's doctrine of specific nerve energies to the technology of nineteenth-century modernity is made particularly clear by Helmholtz:

Nerves in the human body have been accurately compared to telegraph wires. Such a wire conducts one single kind of electric current and no other; it may be stronger, it may be weaker, it may move in either direction; it has no other qualitative differences. Nevertheless, according to the different kinds of apparatus with which we provide its terminations, we can send telegraphic dispatches, ring bells, explode mines, decompose water, move magnets, magnetize iron, develop light, and so on. The same thing with our nerves. *The condition of excitement which can be produced in them, and is conducted by them, is . . . everywhere the same.* [13]

Far from the specialization of the senses, Helmholtz is explicit about the body's indifference to the sources of its experience and of its capacity for multiple connections with other agencies and machines. The perceiver here becomes a neutral conduit, one kind of relay among others to allow optimum conditions of circulation and exchangeability, whether it be of commodities, energy, capital, images, or information.

The collapse of the camera obscura as a model for the status of an observer was part of a much larger process of modernization, even as the camera obscura itself was an element of an earlier modernity. By the early 1800s, however, the rigidity of the camera obscura, its linear optical system, its fixed positions, its categorical distinction between inside and outside, its identification of perception and object, were all too inflexible and unwieldy for the needs of the new century. A more mobile, usable, and productive observer was needed in both discourse and practice—to be adequate to new uses of the body and to a vast proliferation of equally mobile and exchangeable signs and images. Modernization entailed a decoding and deterritorialization of vision.

What I've been trying to do is give some sense of how radical was the reconfiguration of vision by 1840. If our problem is

vision and modernity we must look first at these early decades, not to modernist painting in the 1870s and 1880s. A new type of observer was formed then, and not one that we can see figured in paintings or prints. We've been trained to assume that an observer will always leave visible tracks, that is, will be identifiable in terms of images. But here it's a question of an observer who takes shape in other, grayer practices and discourses, and whose immense legacy will be all the industries of the image and the spectacle in the twentieth century. The body which had been a neutral or invisible term in vision now was the thickness from which knowledge of vision was derived. This opacity or carnal density of the observer loomed so suddenly into view that its full consequences and effects could not be immediately realized. But it was this ongoing articulation of vision as nonveridical, as lodged in the body, that was a *condition of possibility* both for the artistic experimentation of modernism and for new forms of domination, for what Foucault calls the "technology of individuals."[14] Inseparable from the technologies of domination and of the spectacle in the later nineteenth and twentieth century were of course film and photography. Paradoxically, the increasing hegemony of these two techniques helped recreate the myths that vision was incorporeal, veridical, and "realistic." But if cinema and photography seemed to reincarnate the camera obscura, it was only as a mirage of a transparent set of relations that modernity had already overthrown.

Notes

1. John Locke, *An Essay Concerning Human Understanding* (New York: Dover Publications, 1959), vol. 2, xi, 17.

2. Ibid., vol. 2, iii, 1.

3. Richard Rorty, *Philosophy and the Mirror of Nature* (Princeton: Princeton University Press, 1979), pp. 49-50.

4. René Descartes, *The Philosophical Writings of Descartes*, trans. John Cottingham

et al. (Cambridge: Cambridge University Press, 1984), vol. 2, p. 24.

5. Johann Wolfgang von Goethe, *Theory of Colours,* trans. Charles Lock Eastlake (Cambridge, Mass.: The MIT Press, 1970). See my "Techniques of the Observer," *October,* no. 45 (Summer 1988).

6. Michel Foucault, *The Order of Things* (New York: Pantheon Books, 1971), pp. 318-320.

7. Georges Canguilhem, "Qu'est-ce que le psychologie," in his *Etudes d'histoire et de philosophie des sciences,* 5th ed. (Paris: J. Vrin, 1983), pp. 377-378.

8. See Gustav Fechner, *Elements of Psychophysics,* trans. Helmut E. Adler (New York: Holt, Rinehart and Winston, 1966).

9. Fredric Jameson, *The Political Unconscious: Narrative as a Socially Symbolic Act* (Ithaca, N.Y.: Cornell University Press, 1981), pp. 62-64.

10. See Johannes Müller, *Handbuch der Physiologie des Menschen* (Coblenz: Holscher, 1838); *Elements of Physiologie,* trans. William Baly (London: Taylor and Walton, 1848).

11. See Karl Marx, *The Economic and Philosophic Manuscripts of 1844,* ed. Dirk J. Struik, trans. Martin Milligan (New York: International Publishers, 1964), pp. 140-141.

12. Müller, p. 1064.

13. Hermann von Helmholtz, *On the Sensations of Tone as a Physiological Basis for the Theory of Music,* 2nd ed., trans. Alexander J. Ellis (New York: Dover Publications, 1954), pp. 148-149.

14. Michel Foucault, *Discipline and Punish: The Birth of the Prison,* trans. Alan Sheridan (New York: Vintage Books, 1975), p. 225.

Martin Jay I found your paper very rich, but I want to push one aspect of it—the binary opposition between veridical and non-veridical sight—more than you did. It might be argued that the Cartesian perspectival tradition—your tradition of the camera obscura—was aware to some extent of the constitutive, rather than the merely reflective, nature of visual experience. For example, John Yolton, in his book *Perceptual Acquaintance from Descartes to Reid,* deals with the semantic element in Descartes's *Optics;* and here he argues (against Richard Rorty) that even in this "mirror of nature" tradition there is a constitutive moment that has to do with a natural geometry of the mind which is not simply "out there"—that even in this most veridical tradition of vision there is a nonveridical element or at least one that is not simply mimetic. Now I think you are right to say that the introduction of the body emphasizes this constitutive quality that was hitherto relatively forgotten. But I want to ask if the result is completely nonveridical or rather a complex mixture of the constitutive and the reflective, so that vision does not simply become reduced to the stimulation of nerves but also has to do with an external reality which is in a complicated way reproduced—so that there is a mimetic moment that survives even after this revolution that you described so nicely. In short, does the binary opposition of the veridical and the nonveridical hold up? Or are there qualities of each in the two epochs that you sketched?

Jonathan Crary My use of these two very distinct typologies simplifies many of the complexities of the theories of vision in question. In the nineteenth century, vision was most often described in terms of mimetic *and* subjective elements. Some theorists after Müller sought to reintroduce a dependable representational

structure onto mere sensory data, for instance Helmholtz's notion of "unconscious inference" and Hermann Lotze's "theory of local signs." Nonetheless, I still insist that what is new in the nineteenth century is the emergence of the body as a productive physiological apparatus; and if vision in the nineteenth century is thought of as "constitutive," this means something radically different from what John Yolton means. The articulation of subjective vision in the 1830s and 1840s—that is, of the subject's productive role in the process of vision—coincided with a new network of techniques and institutions by which visual experience could be produced *for* a subject. So the emergence of theories of nonveridical perception should be considered in relation to processes of modernization that are specific to the nineteenth century. That is, the abstraction and exchangeability of visual experience is not unconnected to economic and social transformations.

Jacqueline Rose I have a question about the accusation of psychologism launched against the theories you described. As far as I understood it, this could be seen simply in terms of perceptual misapprehension. Did this psychologism, in either its positive or its negative renderings, contain a theory of sexuality or of psychic life, or was it entirely confined to the realm of perception accurately or inaccurately registered?

Crary It depends what you mean by "psyche." In a sense, some of what I was talking about in the nineteenth century comes under the general label of "psychophysics," and yes, it was very much a theory of psychic life and functioning. This is lodged in a more general development of empirical theories of an unconscious from J. F. Herbart to Fechner and Wilhelm Wundt. But all of this is probably very different from what you mean.

Rose And no concept of sexuality is present either?

Crary Certainly not in a major way. I've been speaking mainly about developments between 1820 and 1840. We would have to talk about just what a "concept of sexuality" would mean at that historical moment. Probably not what it does for us now.

Rose I'm just looking for a trace. Is this particular theory of physiological misapprehension with its multiplicity of registers and its lack of coherent inference — is this model of "nerves and brains" ever a sexualized notion of psychic functioning? In eighteenth- and nineteenth-century discussions of hysteria, the distinction between function and organic disorder is immediately bound up with a theory of specifically feminine disorder. Does anything of that kind occur in this realm as well?

Crary No.

Norman Bryson You made one very suggestive reference to Turner. I wonder whether the legacy of the observer constructed in the nineteenth century is to be located mainly in cinema and photography, or whether there are traces in painting (other than Turner) where one might find this construction at work.

Crary I was a bit reluctant to even mention Turner because he is so overused as an example. But in the context of the discussion this morning, part of Turner's work represents the triumphant reemergence of a kind of countertradition to geometrical optics and perspective, that is, the practice born out of the *sfumato* of Leonardo. Yet Turner's work is bound up, as Michel Serres has shown, in a whole new scientific paradigm. In general, there is no immediate homologous relation between science and artistic practice; there is a lag, a phase in which older conventions and techniques lose their effectiveness.

Your larger question — that is, whether we should look for a nineteenth-century observer in film/photography or painting —

raises a set of other issues. I'm very deliberately trying to re-frame the whole problem of the observer by severing it from the kinds of questions art history has usually asked. Rather than let a history of an observer be defined in terms of the changing forms of visual representations (which gives art works a kind of ontological priority), I think of an observer as an amalgam of many disparate events and forces. If it could be said that there is an observer specific to the nineteenth century, it is only as an *effect* of a heterogeneous network of discursive, social, tech-nological, and institutional relations. There is no observer prior to this continually shifting field; the notion of an observer has meaning only in terms of the multiple conditions under which he or she is possible.

Hal Foster Jonathan, on the one hand, you say that in the nine-teenth century vision comes to be known as produced in the body, that it becomes regarded as somehow autonomous, sepa-rated from any referent, and you suggest that this is a precondi-tion of the modernist move that culminates in abstraction. On the other hand, this modernist move is usually seen in terms of a *dis*embodiment of vision. Is there a way to clarify this, or is it not really a contradiction?

Crary I wanted to sketch out in a more general way some of the preconditions for modernism, one of which was the breakdown of the representational model of the camera obscura on many different levels in nineteenth-century culture. It is part of a modernizing of vision which begins very early on—a kind of clearing away, a casting off of old encumbrances that allows for new notions of what is possible for a viewer. And various ideas of autonomous vision and abstraction are certainly part of this. Of course, you are right that many modernist articulations of au-tonomous vision or of pure visuality totally excluded the body,

though the extent to which they "dis-embody" vision really depends on the specific case in question. Van Gogh is a different problem from Pissarro; Theodor Lipps is different from Maurice Denis. But they still depend on the models of subjective vision and of nonveridical perception that emerged earlier, and these models were bound up in massive transformations to the notions both of subjectivity and of production.

Pablo Picasso. *Le Déjeuner sur l'herbe d'après Manet*, July 10, 1961. Staatsgalerie Stuttgart. (Copyright ARS N.Y./SPADEM, 1988)

Rosalind Krauss

THE IM/PULSE TO SEE

Trahit sua quemque voluptas: l'un s'identifie au spectacle, et
l'autre donne à voir.

—Jacques Lacan

What I'd like to broach here is the issue of a rhythm, or beat, or
pulse—a kind of throb of on/off on/off on/off—which, in itself,
acts against the stability of visual space in a way that is destruc-
tive and devolutionary. For, as I hope to show, this beat has the
power to decompose and dissolve the very coherence of form on
which visuality may be thought to depend.

This rhythm turns out to have been the resource of a vari-
ety of works that appeared against the background of early
twentieth-century modernism in direct contestation of that
modernism's ambition to ground the visual arts on a particular
notion of the autonomy of vision. That that autonomy is not se-
cured simply in relation to matters of space, but depends as well
on very particular limits set on the experience of time, can be
demonstrated in a variety of ways. Perhaps the simplest might be
to illustrate it with an anecdote.

Drawn from the art world of the early 1960s, this involves
a story that a critic, Michael Fried, told about an artist, Frank
Stella. It opens with a question. "Do you know who Frank
thinks is the greatest living American?" Michael asked me one
day. And then, grinning at the sheer brilliance of the answer, he
said it was Ted Williams, the great hitter for the Red Sox. "He
sees faster than any living human," Michael said. "His vision is
so fast that he can see the stitching on the baseball as it comes

over the plate. Ninety miles an hour, but he sees the stitches. So he hits the ball right out of the park. That's why Frank thinks he's a genius."

I remember the urgency in Michael's voice as his tone was divided by total hilarity at the image and utter seriousness about its import. But it was the early '60s and I was in the grip of a certain view of modernism and so its import did not escape me either. I too found it a completely brilliant idea: Ted Williams, the spectacular home run hitter, the perfect metaphor of visual modernism.

If at this moment the image does not come across with the effortless immediacy it did then, this would not be surprising, since the grip modernism has on our intuitions has begun for some time to slacken. But for me—then—the image performed the condition of an abstracted and heightened visuality, one in which the eye and its object made contact with such amazing rapidity that neither one seemed any longer to be attached to its merely carnal support—neither to the body of the hitter, nor to the spherical substrate of the ball. Vision had, as it were, been pared away into a dazzle of pure instantaneity, into an abstract condition with no before and no after. But in that very motion-less explosion of pure presentness was contained as well vision's connection to its objects, also represented here in its abstract form—as a moment of pure release, of pure transparency, of pure self-knowledge.

Thus in the early '60s, the image of Williams's heightened vision conjured those very aspirations toward what Clement Greenberg had, at just about the same time, outlined as modernist painting's self-critical dimensions: its participation in a modernist culture's ambition that each of its disciplines be rationalized by being grounded in its unique and separate domain of experience, this to be achieved by using the characteristic methods of that discipline both to narrow and "to entrench it more firmly in its area of competence." For painting, this meant

uncovering and displaying the conditions of vision itself, as these were understood, abstractly. "The heightened sensitivity of the picture plane may no longer permit sculptural illusion, or trompe-l'oeil," Greenberg wrote, "but it does and must permit optical illusion. The first mark made on a surface destroys its virtual flatness, and the configurations of a Mondrian still suggest a kind of illusion of a kind of third dimension. Only now it is a strictly pictorial, strictly optical third dimension . . . one into which one can look, can travel through, only with the eye."[1]

Lukács, deploring this technologizing of the body, this need to abstract and reify each of the senses in a submission of human subjectivity to the model of positivist science, would have found nothing to argue with in Greenberg's analysis. He would only have objected to its tone, to its position, which Greenberg shared with Adorno, that in this withdrawal of each discipline into that sphere of sensory experience unique to it, there was something positive, something utopian. For this utopianist modernism was insisting that this sensory stratum newly understood as discrete, as self-sufficient, as autonomous—this very stratification—permitted an experience of rescue and retreat, a high ground uncontaminated by the instrumentality of the world of labor and of science, a preserve of play and thus a model of freedom. And perhaps the pleasure for us at that moment in the '60s in the idea of a high-cultural ambition's being allegorized through a baseball player was just this insistence on the seriousness of this very sense of play.

Now the beat, or pulse, or throb I want to focus on works not only against the formal premises of modernist opticality— the premises that connect the dematerialization of the visual field to the dilated instantaneity or peculiar timelessness of the moment of its perception—but it works as well against a further assumption contained in the anecdote I've just recounted. It ends up challenging the notion that low art, or mass-cultural

Max Ernst. *A Little Girl Dreams of Taking the Veil*, 1930.

practice, can be made to serve the ambitions of high art as a kind of denatured accessory, the allegory of a playfulness that high-art practice will have no trouble recuperating and reformulating on its own terms.

Thus when, in the central image of his 1930 collage novel, *A Little Girl Dreams of Taking the Veil*, Max Ernst places his heroine at the center of an enclosure, which she calls a dovecoat but which we recognize as the drum of a zootrope, he not only presents us with a model of visuality different from that of modernism's, but associates that model quite directly with an optical device which was generated from and spoke to an experience of popular culture. As was the case in many of the components of his collage novels — this one as well as *La Femme 100 têtes* — the underlying element of the zootrope structuring this image was taken from the pages of the late nineteenth-century magazine of popular science called *La Nature*.

Devoted to bringing its audience news of the latest exploits of technology in a whole variety of fields including engineering,

From *La Nature*, 1888.

medicine, anthropology, geology, *La Nature* was particularly ob-
sessed with optical devices—the fruit of recent psycho-
physiological research. Inevitably, in these pages, the devices
important to this research were lifted from the neutral confines
of the laboratory, to be incorporated into the conditions of pub-
lic spectacle, as the stereoscopic slide was visualized, for in-
stance, in terms of a kind of scenic projection (the static fore-
runner of the 3-D movie), or the limited, intimate, personal
viewing-space of the praxinoscope was enlarged and distanced to
fill the screen on an opposite wall.

 As Jonathan Crary has pointed out in his own discussions
of the archaeology of these optical devices, the obvious drive
demonstrated here towards the conditions of modern cinematic
projection should not blind us to the particular experience these
illustrations still make available, an experience that not only con-
jures up the effects of a given illusion but also exposes to view
the means of this illusion's production.[2] So that the acknowl-
edgement that goes on in these pages is that the spectator will

Opposite, top: Max Ernst, *La Femme 100 têtes*, 1929; bottom: from *La Nature*, 1891;
above: from *La Nature*, 1891 and 1882.

Max Ernst. *A Little Girl Dreams of Taking the Veil*, 1930.

occupy two places simultaneously. One is the imaginary identi-
fication or closure with the illusion—as we see, as if they were
unmediated, the cow grazing against the hallucinatory depth of
the stereoscopically distanced stream, or the bobbing gestures of
feeding geese. The second position is a connection to the optical
machine in question, an insistent reminder of its presence, of its
mechanism, of its form of constituting piecemeal the only
seemingly unified spectacle. This double effect, of both having
the experience and watching oneself have it from outside,
characterized the late nineteenth-century fascination with the
spectacle in which there was produced a sense of being captured
not so much by the visual itself as by what one could call the
visuality-effect.

Now this double vantage, occupied by these early viewers
of proto-cinematic devices, was particularly interesting for
Ernst's purposes inasmuch as the model of vision he was intent
on exploring was the peculiarly mediated perceptual field of the
dream. That experience of the dreamer as spectator or witness

From *La Nature*, 1888.

to the scene of the dream as a stage on which he himself or she herself is acting, so that the dreamer is simultaneously protagonist within and viewer outside the screen of his or her vision, is the strangely redoubled form of dream visuality that Ernst wants to exploit. And so it is to a sensation of being both inside and outside the zootrope that Ernst appeals in this image.

From outside the revolving drum, peering through the slits as they pass rhythmically before our eyes, we would be presented of course with a succession of stationary birds performing the majestic flexing of their wings in what would appear to be the unified image of a single fowl.[3] From the drum's inside, however, the experience would be broken and multiplied, analyzed into its discrete, serial components, the result of chronophotography's record of a mechanical segmentation of the continuity of motion. But uniting the experience of both inside and outside is the beat or pulse that courses through the zootropic field, the flicker of its successive images acting as the structural equivalent of the flapping wings of the interior illusion, the beat both constructing

the gestalt and undoing it at the same time—both positioning us within the scene as its active viewer and outside it as its passive witness.

In a certain way we could think of Ernst's image as configuring within the specific space of the dream many of the effects that Duchamp had in fact put into place throughout his own fifteen-year-long devotion to the turning discs of the devices he collectively called *Precision Optics*. There we find the same tapping into forms of mass culture—in this case both the revolving turntable of the phonograph player and the flickering silence of early film—as we also find an explicit reference to the nineteenth-century optics that underwrote these forms. Further, *Precision Optics* bears witness to Duchamp's commitment to the constitution of the image through the activity of a beat: here, the slow throb of a spiral, contracting and expanding biorhythmically into a projection forward and an extension backward. And here as well the pulse is accompanied by what feels like a structural alteration of the image as it is consolidated only continually to dissolve—the illusion of trembling breast giving way to that of uterine concavity, itself then swelling into the projecting orb of a blinking eye. Yet, to speak of metamorphosis, here, is to miss the dysmorphic condition of this pulse, which, committed to the constant dissolution of the image, is at work against the interests of what we could identify as form.

I have, in another context, spoken about the connection between the pulsing nature of the vision Duchamp constructs and the explicitly erotic theater it stages—the sexual implications of the motions of these discs having escaped no commentator on this aspect of Duchamp's production.[4] I have also described what is clearly Duchamp's concern here to corporealize the visual, restoring to the eye (against the disembodied opticality of modernist painting) that eye's condition as bodily organ, available like any other physical zone to the force of eroticization. Dependent on the connection of the eye to the whole

Marcel Duchamp. Above: *Rotorelief No. 1, "Carolles"*, 1935; below: *Rotorelief No. 3, "Chinese Lantern"*, 1935. (Copyright ARS N.Y./ADAGP, 1988)

Alberto Giacometti. *Suspended Ball*, 1930–31, two views. Kunstmuseum Basel.
(Copyright ARS N.Y./ADAGP, 1988)

network of the body's tissue, this force wells up within the den-
sity and thickness of the carnal being, as, tied to the conditions
of nervous life, it is by definition a function of temporality. For
the life of nervous tissue is the life of time, the alternating pulse
of stimulation and enervation, the complex feedback relays of re-
tension and protension. So that the temporal is mapped onto the
figural in the space of Duchamp's *Precision Optics* as the specific
beat of desire — of a desire that makes and loses its object in one
and the same gesture, a gesture that is continually losing what it
has found because it has only found what it has already lost.

To the examples of Ernst and Duchamp a third instance
might be added, if only to gain a sense of the way this figuration
of a pulse functioned rather widely within the '20s and '30s as
an alternative to or protest against the claims of modernist op-
ticality to have both abstracted vision and rationalized form. I
am thinking of the sculpture by Giacometti called *Suspended Ball*,
where the work is organized around the pendular motion of an
orb rhythmically sliding over the recumbent form of a wedge,
the construction as a whole cast in terms of the anodyne sim-

plicity of a child's toy. That the two elements in the sculpture are extremely genital is as obvious here as it had been in the case of Duchamp's *Rotoreliefs*. But what is less easy to assert is the gender identity of either form. So that the oscillation figured in the work through the back-and-forth of its rhythmic arc operates as a temporal analogue to the shifting undecidability of its definition of male and female, the sculpture thus asserting itself as a machine geared to the collapse of sexual difference. And as this little guillotine of castration works once again in relation to a beat, its pulse can be seen to be operating in a way that is deeply inimical to the stability and self-evidence of form, to the permanence—we could say—of the good gestalt.

If the gestalt operates as a kind of absolute in the field of vision, as the principle of concordance between difference and simultaneity—that is, the simultaneous separation and intactness of figure and ground—the beat could, from the point of view of a modernist logic, never be anything more than an interloper from the domain of the temporal, the auditory, the discursive. A function of time and of succession, this beat would be something that modernism had solemnly legislated out of the visual domain, asserting a separation of the senses that will always mean that the temporal can never disrupt the visual from within, but only assault it from a position that is necessarily outside, external, eccentric. Yet the power of the works that interest me here—in their contestation of what modernism had constructed as "the visual"—is that this beat or pulse is not understood to be structurally distinct from vision but to be at work from deep inside it. And from that place, to be a force that is transgressive of those very notions of "distinctness" upon which a modernist optical logic depends. The beat itself is, in this sense, figural—but of an order of the figure that is far away from the realm of space that can be neatly opposed to the modality of time.

To discover and theorize this order is part of the task Jean-François Lyotard set himself in the work *Discours, Figure*. There

he argued that below the "seen" order of the image (that is, the object bounded by its contour) and below the "visible but unseen" order of the gestalt, which we could call the formal conditions of possibility of visualizing the object, there lies the order of the "invisible," to which Lyotard gives the name *matrix*.[5]

Belonging to the unconscious, the matrix is the form of the primary process as it operates invisibly, behind the constraints of repression, such that only its fantasmatic products ever surface onto the field of the visible. The matrix can, then, only be inferred, only be reconstructed from the figuration provided by fantasy. But as such the matrix can be seen to possess certain qualities. First, it involves a spatiality that is unassimilable to the coordinates of external space: for in this space of the unconscious, Lyotard remarks, "places are not *partes extra partes;* the intervals required for example in the perceptual order for things of the external world to be recognizable and for them not to pile up on one another—depth in short—or, in terms of phenomenological transcendence, negation—here these intervals are abandoned."[6] But this condition of superimposition and simultaneous presence means that the matrix, even though it possesses features we identify with the nature of the structural order—namely invisibility and synchrony—cannot be understood in terms of structure. For the matrix does not order and regulate difference, maintaining oppositions in a rule-governed system; rather, it courts the transformation of everything into its opposite, thereby undermining the productive work of structure. So that its second feature is that the elements of the matrix "do not form a system but a block":

If the matrix is invisible, it is not because it arises from the intelligible, but because it resides in a space that is beyond the intelligible, is in radical rupture with the rules of opposition . . . It is its characteristic to have many places in one place, and they block together what is not compossible. This is the secret of the figural: the transgression of the

constitutive intervals of discourse, and the transgression of the constitu-
tive distances of representation. [7]

The third feature of the matrix is its formal condition as rhythm
or pulse, a condition that might seem to push the matrix out of
the realm of the figural altogether and into that of time. That it
does not do so will become evident from the example of the ma-
trix that Lyotard submits to analysis. [8]

"A Child Is Being Beaten" was the description given to
Freud by several patients who located this as an obsessional,
erotic fantasy. [9] As we know, all that analysis could draw from
the particular patient Freud describes was another, more primi-
tive version of the fantasy, enunciated as "The father beats the
child." In relation to this latter statement the only added infor-
mation was that here the child the father was beating was not
the patient herself, but another child; and as for the patient, she
was stationed as witness. There are several senses in which *ein
Kind wird geschlagen* serves Lyotard as a matrix figure. One of
them is the total invisibility of one of its key terms, one that lay
so deeply repressed that it had to be extrapolated or recon-
structed by Freud. This is that phase of the fantasy which, as it
were, puts its erotic spin on it, investing it with both its excite-
ment and its anxiety. It is the phase that the patient never artic-
ulated but which Freud ventriloquized as "I am being beaten by
the father."

But it is precisely from the perspective of that intermedi-
ary phase—the one between "the father beats the child" and "a
child is being beaten"—that the multiple transmutations at work
in the production of the fantasy become apparent: the trans-
mutation from active to passive—as beating turns into being
beaten; the transmutation in the field of the subject—as specta-
tor turns into victim; the transmutation in libidinal zone—as
genitality reverts to anality; the transmutation in the contents of
the drive—as sadism changes to masochism. And it is this work

of overlaying contradiction, of creating the simultaneity of in-compossible situations, that Lyotard identifies as the action of the matrix. If it is a matrix, Lyotard maintains, it is because

the statements one can determine there which organize the goal (to beat), the source (the anal zone), and the object (the father) of one sentence, are in their turn condensed into a single product-formula — "A child is being beaten" — whose apparent coherence allows the psychic life to contain in a single manifold a multiplicity of incompossible "sentences." These do not form a system but a block. Thus the drive to be and to have the father is simultaneous; and the investment is both genital-phallic and sadistic-anal.[10]

The matrix's invisibility is secured, then, by the very activity of the changes it produces, of the constant nonidentity of its component parts. Yet the product of the matrix is an obsessional fantasy, a recurrence which, in each of its repetitions, is the same. And this leads Lyotard to ask how this identity is secured since at the level of the fantasy's contents there is nothing that is maintained as stable. To this he replies that its identity is formal. "The fantasmatic matrix," he says, "is evidently a 'form.'" Yet the difficulty of thinking this producer of disorder and disruption as a form is obvious. "How in general," Lyotard asks, "can that which is form also be transgression? How can what is deviation, derogation, deconstruction, be at the same time form?"[11] The answer he finds is in the evidence of a form that is not a good form, not a good gestalt. Rather, as he shows, "it is a form in which desire remains caught, form caught by transgression; but it is also the, at least potential, transgression of form."[12]

This form, which is that of on/off on/off on/off, is the alternating charge and discharge of pleasure, the oscillating presence and absence of contact, the rhythm "in whose regularity the subject's unconscious is, so to speak, 'caught,' the formal matrix of both dreams and symptoms." It is onto this form that the ma-

trix figure's fantasized gesture of a spanking that is also a caress can be mapped; for it is this form that can represent the rhythmic oppositions between contact and rupture. But Lyotard cautions that, unlike a pulse which is understood in terms of a law of repetition, a principle of recurrence guaranteeing as it were that an "on" will always follow an "off," this pulse involves the constant threat of interruption. The anxiety that is part of the affect of "A Child Is Being Beaten," combining with its erotic pleasure, arises precisely from the force of rupture that is recurrent in the rhythm of the figure, a rupture which is not experienced as the onset of yet another contact, but as an absolute break, that discontinuity without end that is death. Thus it is the death drive, operating below the pleasure principle, that transcodes this rhythm—as it beats with the alternation between pleasure and extinction—into a compulsion to repeat. The matrix is, then, the form that figures recurrence.

The beating of the zootrope, cranking up to speed, the beating of the gull's wings within the imaginary space, the beating of all those mechanical devices through which the real appears to burst into life from the shards of the inorganic and deathly still, and the particular form of the pleasure connected to that rhythm, became, as I have been claiming, a particular resource for artistic practice. Focused simultaneously on the unconscious ground of that pleasure and on its media-form, which is to say its relation to mechanical reproduction, the artists I've been speaking of were concerned, although not all equally so, with the vehicles of mass culture.

The analysis of the gesture into its incremental displacements, as the same static form is slowly maneuvered along the page of the animation stand; the mechanical process of creating the minute variations that can be jerked into motion by their passage through the camera's gate or by the even cruder rifling of pages in the common flipbook—all this, as a resource of the beat, seems miles away from that wholly different high-art prac-

Pablo Picasso. *Le Déjeuner sur l'herbe d'après Manet,* July 10, 1961. Staatsgalerie Stuttgart. (Copyright ARS N.Y./SPADEM, 1988)

tice of what we think of as the creative generation of variations on a theme. But I would like to turn to this practice of variation, and to the assumption (which is the operative notion of the art historian) that, within the age of mechanical reproduction, variation—as resource of voluntary repetition, the outpouring of the controlled play of difference—is secured against the rhythmic pull of the beat.

Within twentieth-century art Picasso is perhaps the great practitioner of the theme and variation. Indeed we could say that the whole last period of his production, which is to say his work's final two decades, is structured around the variations he did on old-master paintings—the *Femmes d'Alger,* the *Meniñas,* the *Raphael and the Fornarina,* the *Déjeuner sur l'herbe.* To speak of its being structured around these older works is not just to acknowledge the way that these pictures—by Delacroix, Velázquez, Ingres, Manet—provided Picasso with the compositional ideas he no longer seemed able to derive from life. More than that, it

is to see the way they functioned as the armatures for a peculiar
kind of pictorial production: the spinning out of hundreds of
"preparatory studies" through which the given composition
could be thought to be varied over the time of the artist's cre-
ative attention, sustaining and tracking the bursts of his imagina-
tive energy. This is of course the way these studies have been
described in the unbearably sycophantic literature on Picasso, as
in the following passage where Douglas Cooper discusses the
sketches leading toward one of Picasso's versions of the *Déjeuner
sur l'herbe:*

*During the three days from the 7th to the 10th of July Picasso gave
himself up to a period of intense creative work on the* Déjeuner. *In
that short time he drew no less than 28 new compositional studies —
18 of them in one day — and executed a second definitive variation in
oils. These drawings reveal even more than those which preceded them
the concentration of [Picasso's] thought. . . . Here we see him working
with the fervour and conscientiousness of a Cézanne. We find him re-
peatedly correcting himself and starting again. . . . Things are changed
around ever so slightly [as] an arm or a leg will be moved for the sake
of the general design. . . .*

And, Cooper concludes this description, as though we had here
to do with the compositional study or bozzeto as it had existed
from the time of the Renaissance, "So much for the actual draw-
ings — many of them masterly — and the role they were called on
to play. . . ."[13]

But what are these actual drawings — eighteen of which
Picasso was able to produce in just one day?

The sketchbooks Picasso filled in the two-and-a-half years
of his work on the *Déjeuner,* each page carefully maintained in
sequence by its meticulous dating and numbering, are produced
in the manner of the animation stand, as the drawing on each
page — incised into its soft, thick paper with sharp penciled
lines — embosses its contours into the page below it, that new

page etching its own configuration into the succeeding level of
the sketchbook, and so on. The mode of production Picasso
adopts here is not that of the successive upsurge of renewed in-
spiration but that of the mechanically reproduced series, each
member of which sustains those minute variations that seem to
animate the group as a whole. But this animation is not on the
order of the old organic metaphor applied to compositional uni-
ties. It is an animation that relates to the production of cartoon
drawings. And indeed in the exploration of successive layers of
the sequence—as peeling them back one from the next we see
the tiny anatomical shifts and swellings—we have the impression
not so much of watching an idea in development as of observing
gesture in motion. Thus quite unexpectedly, we feel ourselves to
be in the presence of a flipbook.

Much of the energy expended by Picasso's admirers, when
speaking of these compositions based on the work of others, is
focused on extricating the master from the toils of the origi-
nal—insisting that he is not caught in the trap of the earlier
model. "A painter of genius," Cooper assures us, "seems to have
the capacity to surrender voluntarily to inspiration deriving
from another work of art and then, escaping from it, find his
imaginative strength renewed and capable of projecting an image
of his own."[14] This discussion of surrender and capture, even
though it is always climaxed by reassurances about the artist's
freedom, betrays, I would say, a kind of anxiety about Picasso's
enterprise in these works, even while it utterly mistakes the na-
ture of the "surrender" involved. For the surrender of the art-
ist's imagination, the place in which it is caught by being given
over to pleasure, is the function of a voluptuous passivity: the
mechanism of the serial animation of the flipbook's beat.

Nowhere is this voluptuous succumbing to the unconscious
productivity of the device clearer than in the sketchbook Picasso
made as a kind of climax towards which all the others were
leading, the sketchbook of August 2, 1962, which both Cooper

Pablo Picasso. Studies for *Le Déjeuner sur l'herbe d'après Manet.* Above: April 7, 1961, I;
below: April 7, 1961, II. (Copyright ARS N.Y./SPADEM, 1988)

Pablo Picasso. Studies for *Le Déjeuner sur l'herbe d'après Manet.* Above: February 8, 1962, I; February 8, 1962, II. (Copyright ARS N.Y./SPADEM, 1988)

and Zervos thought it best not to reproduce.[15] Here the erotic investment in the scene is made as explicit as possible, as through nine successive pages the orgiastic subtext of the *Déjeuner* is enacted, the important variations within this repeated appearance and disappearance of the scene being the migration of the actors' genitals to various sites on their bodies.

The monstrance of the genitals within this matrix of the flipbook form can, moreover, be seen to be what much of the preceding two hundred sketches had been preparing for. Cooper speaks of Picasso's long-held fascination with the figure of the woman bending over and seen from above — bending to tie her sandal, to dry herself, or as here, to bathe. In the *Déjeuner* sequence he sees her presence as the nub of the matter for Picasso, whether or not her scale is reduced in relation to the others. And indeed the figure viewed in this position is, as Robert Rosenblum signaled in his article on the anatomy of Picasso's eroticism, vulnerable to the transmutation that Picasso repeatedly performs on it, whether we look at the keening Magdalene from the *Crucifixion* or the bather from the *Déjeuner*.[16] The female head, bent to project below the breasts, submits again and again to the same transformation, as it is recast as phallic signifier, the stand-in — mapped onto the nose and hair of the female face — for the genitals of an absent male.

That Picasso should have pursued this image over many years, that he should have had frequent and spectacular recourse to the depiction of sexual acts, could lead one to object that he certainly did not *need* the flipbook structure for permission to vent the erotic turn of his imagination. And I would agree that he did not need it. But I think that as at the end of his life it became the medium of his activity, he did indeed become caught in its mechanism, his art becoming more and more a function of its *pulse*. And so though he did not need it he yielded to it, to the appeal of pure recurrence, to the seduction and the content of an endless pulse. The mechanically repeated and the erotically

enacted seemed to have trapped him, and he created the meta-
phors of this capture. In 1964 he made some ceramic tiles on
each of which a priapic satyr pursues a nymph with the repeti-
tive exactitude a template provides. He was showing Hélène
Parmelin the dozen or so examples he had made and he asked
her, "Wouldn't it be pretty to have entire rooms tiled like that?"
She includes this remark in a section of her book titled "Picasso,
the Moralist."[17]

"Picasso, the Moralist" could be the subtitle of almost
every book on Picasso over the past fifty years, bringing to us
over and over again the message of art's assurance about volun-
tarism, intentionality, and freedom. No one listens to Picasso
himself as he speaks, in all innocence, of the way he is possessed
by the *dispositif* he has constructed. Acknowledging that "with
the variations on the old masters [Picasso] systematizes the pro-
cess; the work is the ensemble of the canvases on the same
theme and each one is only a link of the whole, a suspended
moment of creation," one of the writers on this phase of his
work quotes him saying that what interests him "is the move-
ment of painting, the dramatic push of one vision to the next,
even if the push is not forced to its conclusion . . . I have arrived
at the point where the movement of my thought interests me
more than my thought itself."[18] The passivity of this interest
comes out in another remark, where he says, "I make a hundred
studies in several days, while another painter might spend a
hundred days on a single picture. In continuing, I will open
windows. I will get behind the canvas and perhaps something
will happen."[19] "Quelque chose," he says, "se produira." The
window will open and something will happen before the eyes of
the painter who is caught there, fascinated—like the Wolf Man
for whom the window opens onto that beyond where something
takes place, as it displays for him the matrix-figure of a scene in
which he will be, for the rest of his life, entrapped.

Notes

1. Clement Greenberg, "Modernist Painting," in *The New Art*, ed. Gregory Battcock (New York: Dutton, 1966), p. 107.

2. Jonathan Crary, "Techniques of the Observer," *October*, no. 45 (Summer 1988).

3. The zootrope illustration Ernst uses here appears in an article on Jean-Etienne Marey's chronophotographic recording of a bird in flight, from which three-dimensional models were eventually constructed. See *La Nature* (1988): 12.

4. See my "The Blink of an Eye," forthcoming in *Nature, Sign, and Institutions in the Domain of Discourse*, ed. Program in Critical Theory, University of California (Irvine: University of California Press).

5. Jean-François Lyotard, *Discours, Figure* (Paris: Editions Klincksieck, 1971), p. 283.

6. Ibid., p. 338.

7. Ibid., p. 339.

8. The analysis of this fantasy is conducted under the chapter heading "Fiscours Digure," ibid., pp. 327-354.

9. Sigmund Freud, "A Child Is Being Beaten" (1919), in *Sexuality and the Psychology of Love*, ed. Philip Rieff (New York: Collier Books, 1963).

10. Lyotard, pp. 338-339.

11. Ibid., p. 349.

12. Ibid., p. 350.

13. Douglas Cooper, *Pablo Picasso: Les Déjeuners* (New York: Harry N. Abrams, 1963), p. 19.

14. Ibid., p. 23.

15. The sketchbook is catalogued as no. 165, in *Je suis le cahier: The Sketchbooks of Pablo Picasso*, ed. Arnold Glimcher and Marc Glimcher (Boston: Atlantic Monthly Press, 1986), where two images from this sequence are illustrated.

16. Robert Rosenblum, "Picasso and the Anatomy of Eroticism," in *Studies in Erotic Art*, ed. Theodore Bowie and Cornelia V. Christenson (New York: Basic Books, 1970), figure 198.

17. Hélène Parmelin, *Picasso: The Artist and His Model* (New York: Harry N. Abrams, n.d.), p. 153.

18. Marie-Laure Bernadac, "Picasso, 1953-1973: La peinture comme modèle," in *Le dernier Picasso* (Paris: Musée National d'Art Moderne, 1988), p. 49.

19. This remark is used, although to support a wholly different argument, by Douglas Cooper, *Les Déjeuners*, p. 33. It originally appeared in Roland Penrose, *Picasso* (Paris: Flammarion), p. 47.

Jonathan Crary In your thinking about this idea of the pulse or beat, did you consider neoimpressionism and the possibility that that perception of organized color contrasts involved some kind of oscillation or temporal beat? Or is such work within the domain of the purely optical?

Rosalind Krauss In fact I didn't consider it. But this is interesting: Duchamp hated retinal art, yet when he talked about it—always to belittle it—he wanted to exempt two artists who he thought might otherwise be confused with it. One was Mondrian, the other was Seurat. The Mondrian part I can understand, but the Seurat part has always mystified me—and you have just explained it.

Martin Jay I have a question concerning a musical parallel to the beat or pulse. During the modernist period there is a move away from theme and variation towards a stress on rhythm; one thinks of Stravinsky in particular. One might argue that this is the replacement of one type of musical form by another type, and to this extent perhaps the move towards rhythm or pulse in visual terms is not so much a critique of form per se as it is an introduction of a different model of form, already there in music, which is temporal; and this is somewhat different from the absolute breakdown of form which one finds perhaps in atonal music. So is there a way to conceptualize this in terms not of rhythm as opposed to form but of rhythm as a different type of form?

Krauss When Lyotard talks about rhythm in his discussion of the matrix, he insists that it is *figural*—not a temporal rhythm. For example, he thinks about patterns of columns on a facade, the

way in which they set up a rhythm. He doesn't want this idea to leak out into the temporal and so once again set up a modernist condition of separate domains.

Now as for the musical analogy: one could think of twelve-tone composition in terms of the figural, that is, in terms of a structure that has the potential of a simultaneity or overlaying that is connected to figurality. But that's just a guess.

Jacqueline Rose There seems to me to be an interesting difference between concepts like "beat," "pulse," "throb," and "matrix," and the following-through of the stages of fantasy in "A Child Is Being Beaten." How do these concepts work together, or is there a tension between them?

Krauss I assume you are referring to the temporality of the narrative reconstruction of the fantasy. Now Lyotard insists on the very figurative compactness of this fantasy, which doesn't seem to include a narrator or an agent of the beating—and it is even vague about the nature of the child. That compacted block, which is then reconstructed according to its contradictory, shifting components, creates a paradox, one which is not containable within the field of vision or three-dimensional space. It is a fluid, amorphic, even dysmorphic thing.

Rose This touches on a tension which seems to be present in the work of Lyotard between concepts like "discourse" and "figure" on the one hand, and "libidinal economy" on the other. The concept of libidinal economy seems to me available for an almost physiological account of the substrata of conscious perception and identity. And that's where words like pulse, throb, etc., could then be pulled in the direction of concepts like that of the "semiotic" in Julia Kristeva's work. In short, there is a kind of lyricism to what we oppose to the dominant psychic trope. Whereas what struck me in your example of "A Child Is

Being Beaten" is that there is always already a fantasy in place, so that even if we try to put ourselves outside a certain visual register we still call up forms of nonidentification which are nonetheless positionalities. Now whatever one wants to say about that (and I agree with you that it's not the same form of narrative structure), I don't think that account is available for the idealization that goes on within certain other concepts of what a matrix might be.

Audience (Bernard Flynn) I have a question for Martin Jay. I was somewhat surprised that you see Descartes as the initiator of a regime of the visual. It seems to me that his texts could be read just as well in a radically, militantly antivisual sense. Think of what becomes of the piece of wax in the *Meditation:* all the information that one gets through the senses is false, is never reinstated. And even in the *Optics,* in his theory of perspective (as Merleau-Ponty reads it in "The Eye and the Mind"), one doesn't see anything at all, one judges. The mind may survey the brain and then generate a perspective-effect—but not really by sight so much as by mathematical judgment. In fact, Descartes even uses the metaphor of the text: that one reads the brain.

Martin Jay This is an excellent question; it gives me an opportunity to clarify the dimension of the visual in Descartes. One could say the same thing about Plato: that he too was hostile to the illusions of the senses and was anxious to defend the alternative of the mind's eye. Cartesianism contains this dualism as well, for Descartes also gives us a critique of the illusions of observation. But in its place he provides a notion of the mind as visually constituted. For Descartes the mind contains "clear" and "distinct" ideas, and clarity and distinctness are essentially visual terms. Moreover, the mind perceives natural geometry, which is commensurate with the geometry that underlies our actual empirical sight. Descartes believes in the commensurability of these two realms (which I could also characterize in terms of two notions of light, luminous rays or *lux* and perceived *lumen*); it enables him to argue that inventions like the telescope are valuable because they show us visual experience which is commensurate with that of natural geometry.

Now the issue of judgment, the issue of the text, is also very interesting. It relates to the point I made earlier regarding the semantic dimension of vision. You are right: Descartes uses rhetorical and linguistic explanations that take us away from a purely imagistic notion of the mind's eye or of actual eyes. But it is almost always done in the service of a strong notion of mental representation where one sees (as he puts it) "with a clear mental gaze." So what is at issue is neither actual empirical observation (which Merleau-Ponty, with his emphasis on the body and binocular vision, wants to restore), nor is it an entirely rhetorical, semantic, judgmental, or linguistic alternative. It is a third model, which again I think is parallel to the Platonic tradition of mental representation—of the mind's eye, of the purity of an optics which is outside actual experience.

Audience (John Rajchman) I have a question for both Jonathan and Martin. I was impressed by your remarks, Jonathan, and I was especially interested in the influence of Foucault upon them. Your use of Foucault is very different from one which presents him as a denigrator of vision, as Martin has in another context ["In the Empire of the Gaze: Foucault and the Denigration of Vision in Twentieth-Century French Thought," in *Foucault: A Critical Reader*, ed. David Hoy]. It is a Foucault who is more concerned with "events" of the visual.

Foucault argued, of course, that abnormality or deviation is a central category in our modern period, especially when it comes to madness. (As Jonathan has mentioned—and Georges Canguilhem talks about this too—Fechner and Helmholtz conceived vision in terms of the normal and the abnormal, and of course they were read by Freud. In fact, in *Beyond the Pleasure Principle*, I believe there are references to both Fechner and Helmholtz.) For Foucault there is a great difference between this

modern conception of madness as abnormal and the Renaissance conception of madness as a marvel or a monstrosity from another world. So when Martin talks about "the madness of seeing" (*la folie du voir*) and suggests, à la Christine Buci-Glucksmann, that this is a reactualization of a baroque vision, I am not sure I agree. The baroque did not possess our category of the abnormal, and our visual irrationality (influenced by the paradigm that Jonathan sketched) is a different sort of thing. So perhaps it is not a reactualization so much as a rethinking of "the madness of seeing" in terms of our own rationality of the abnormal. (To see it in this way, incidentally, would give us a different perspective from the kind of phobia about irrationality that comes from Jürgen Habermas.) Isn't there some kind of clash between these sorts of history?

Jay Your point that Buci-Glucksmann constructs a baroque vision for her own purposes is a valid one, but I think she has also recovered an attitude which is more positive about "madness." Obviously her interpretation is deeply imbued with contemporary concerns—one hears Lyotard, Lacan, and other recent thinkers on every page—so it is not simply an historical account.

Now as for the two registers of madness: *la folie du voir* is a term that has been around for a while (Michel de Certeau also wrote about it). In this sense madness is seen as ecstatic, connected to *jouissance,* as not constraining. My Habermasian note at the end was to suggest that "madness" is neither good nor bad but is a category we need to problematize. This may require a return to a notion that Foucault would find problematic, but it seems to me that he also teaches us to be wary of any return to the body. For Foucault, of course, the body is constituted culturally and historically; therefore we are forced once again to

think about its implications rather than accept it as a solid ground or as some antidote to the false decorporealization of vision.

Jonathan Crary I just want to clarify something. For me the importance of Helmholtz and Fechner for Freud has to do less with delineating the normal and the abnormal than with a certain model of an economy of energy. This is interesting in terms of the position of physiology in relation to other sciences in the nineteenth century. Perhaps the single most important achievement of Helmholtz was his work on the conservation of energy; but he began as a medical student and physiologist, and it was through his study of animal heat that he eventually arrived at his thermodynamic formulations. One of the tasks of physiology in the 1840s was the refutation of vitalism, the idea that somehow living beings operated by virtue of their own unique vital force. In this sense, physiology was an enterprise of making the body equivalent to and exchangeable with other apparatuses and machines. Thus Helmholtz, throughout his career, was to describe a human subject that works, produces, *and sees* within a process of muscular work, combustion of energy, and release of heat according to empirically verifiable laws. What was important was how the body was rendered continuous with its field, making obsolete that split between outside and inside which defined a classical observer.

Audience I have a question for Rosalind Krauss. Do you make a distinction between the picture-making activity of an artist like Picasso and his psychic reality? Do they operate as opposite poles or do they have a mimetic relationship?

Rosalind Krauss In the twenty-three-volume *Oeuvres* of Picasso, thirteen of those volumes are devoted to his last period. What

fills these pages are endless sketches, and no one (as far as I know) has mentioned that they are done in an animation-stand manner where the trace of the image etched onto the page below is used to produce the next image and so on. That process interests me very much — its mechanical nature, the passivity of Picasso before this process (which in a sense was stronger than he). So the whole discussion of erotics in late Picasso, of whether he was a dirty old man or a voyeur, is irrelevant to what we are in fact watching, which is a feeble attempt to erect eros in defense against what was really happening to him — which was death.

Audience So there is no distance on his part from his activity?

Krauss None. I think he had absolutely no distance.

Krauss I have a question for Martin, one that relates to John Rajchman's. I am not sure that seventeenth-century visual regimes can be mapped quite so directly onto late nineteenth- and early twentieth-century practices. Are these weak homologies, or just totally different phenomena? Take your example of the modernist grid and the map presented by Svetlana Alpers as a model for seventeenth-century Dutch painting. The modernist grid is tremendously different from this cartologic grid, for the modernist grid is reflexive: it maps the surface onto which it is projected; its content is that surface itself. A map is not doing that: its content comes from elsewhere; it has nothing to do with the reflexive model.

Another instance is the anamorphic image. Now the opacity that is figured in anamorphosis is a matter of point of view: one can see the image correctly if one can get to the correct position. Whereas the invisibility that arises within modernism is not so obviously physical: it is tinged or affected by

the unconscious, and in this unconscious invisibility there isn't any correct perspective or other vantage point. It can only be reconstructed in the modality of a different form like language. I think that's a weak metaphoric use of the idea of anamorphosis. You seem to accept this Buci-Glucksmann hypothesis; I would think that as an historian you would not.

Jay I share the willingness to problematize these linkages; let me see what this might mean in these two cases. First with the grid. What Alpers tells us is that whereas the perspectival grid is wholly different from the modernist grid, the cartographic grid (which is also present in seventeenth-century Dutch art) is a way-station to the modernist one. It is halfway because it insists not on an illusory reproduction of an external reality but rather on a sign-ordered transfiguration of it. So already there is a kind of conventionality to this grid, an awareness of the necessity of a mode that is not simply mimetic. And to that extent maybe it does point the way to a fully nonmimetic twentieth-century grid.

As for anamorphosis, a satisfactory response would require going into some detail. In his discussion of sight in *The Four Fundamental Concepts of Psycho-analysis,* Lacan is fascinated by the idea of anamorphic vision, as is Lyotard in *Discours, Figure* (significantly, both use the Holbein painting *The Ambassadors,* with its anamorphic skull, on their title pages). In Lacan's discussion of vision one gets a sense of crossed visual experiences, which is what anamorphic vision, if seen in tension with straightforward vision, gives us. So to that extent it helps us understand the complexities of a visual register which is not planimetric but which has all these complicated scenes that are not reducible to any one coherent space.

Finally, as to the Buci-Glucksmann argument: I would agree that one has to take it with a grain of salt; it is written from the perspective of the 1980s, it is not purely an historical exercise. But I think it helps us to see a potential for another vision already there in the Western tradition, even during the heyday of Cartesian perspectivalism. It allows us to see what Jacqueline Rose calls "the moment of unease" which is latent but now perhaps rediscovered in that tradition—even if we have partly concocted it as well.

Figure 1. Jiun. The character "Man."

Norman Bryson

THE GAZE IN THE EXPANDED FIELD

I

In this paper I will be examining a term that has become impor-
tant in contemporary discussions of painting and of visuality: *le
regard,* "the Gaze." First of all I will do what I can to trace the
concept of the Gaze as it passes from Sartre to Lacan, from
Sartre's description of the Gaze of the other in *Being and Noth-
ingness* to Lacan's reworking of that description in the first two
sections of *The Four Fundamental Concepts of Psycho-analysis.* To
some this will be familiar territory, to others it will be less fa-
miliar; I will do my best to proceed as clearly as I can. But once
that account of *le regard,* the Gaze, is stated I want to move to
what may seem at first sight a quite unconnected account of vi-
sion, the one that emerges in the meditation on Western phi-
losophy conducted in Japan principally by Kitarō Nishida and
then by Nishida's student Keiji Nishitani. The reason I wish to
invoke Nishida and Nishitani is that their theoretical develop-
ment seems in many respects to go further than Sartre and
Lacan towards a radical reformulation of our thought on visu-
ality, and as a consequence of this our thought on painting.

My argument will be that the line of thinking that passes
from Sartre to Lacan in crucial respects remains held within a
conceptual enclosure, where vision is still theorized from the
standpoint of a subject placed at the center of a world. Although
that centralized subject is progressively dismantled by Sartre and
Lacan—and the direction of their thought is unmistakeably to-
wards a radical decentering of the subject—there seem to me to
be areas in which the standpoint of the subject as center is actu-

ally retained; the result of that residual centering upon the standpoint of the subject is that vision is portrayed as menaced at that vestigial center, threatened from without, and in some sense *persecuted,* in the visual domain, by the *regard* or Gaze. The direction of thought that passes from Nishida to Nishitani undertakes a much more thoroughgoing displacement of the subject in the field of vision, which finds expression in a term so far largely neglected in the Western discussion of visuality, *śūnyatā,* translated as "blankness," "emptiness," or "nihility." The concept of blankness, as it evolves in the thought of Nishida and then of Nishitani, relocates the Gaze, *le regard,* in an expanded field where a number of conceptual transformations become necessary and urgent: notably concerning the aspect of *menace* which still colors Lacan's account of the subject's visual experience; concerning the question of *where the subject resides,* under the Gaze and in the expanded field of *śūnyatā* or "blankness"; and concerning, in the practice of painting, the repercussions of the structures of *le regard,* the Gaze, and *śūnyatā,* blankness or emptiness, at the level of brush, pigment, and frame.

II

Sartre's conception of the gaze of the other is clearest in his story or scenario of the watcher in the park.[1] Sartre's narrative involves two stages. In its first movement, Sartre enters a park and discovers that he is alone: everything in the park is there for him to regard from an unchallenged center of the visual field. All of the park unfolds before this absolute center of a lived horizon: the subject resides at the still point of the turning world, master of its prospects, sovereign surveyor of the scene. In this initial exhilaration of self-possession, nothing threatens the occupancy of the self as focus of its visual kingdom. But in Sartre's second movement, this reign of plenitude and luminous peace is brought abruptly to an end: into the park and into the

watcher's solitary domain there enters another, whose intrusion breaks the peace and fractures the watcher's self-enclosure. The watcher is in turn watched: observed of all observers, the viewer becomes spectacle to another's sight. Now all the lines of force which had converged on the center of the watcher's lived horizon turn, reverse, and reconverge on the space of the intruder and his irruption. Before, all of the perspective lines had run in from the horizon towards the watcher in the park; now another perspective opens up, and the lines of flight race away from the watcher self to meet this new point of entry. For the intruder himself stands at his own center of things, and draws towards and into himself everything he sees; the watcher self is now a tangent, not a center, a vanishing point, not a viewing point, an opacity on the other's distant horizon. Everything reconverges on this intrusive center where the watcher self *is not:* the intruder becomes a kind of drain which sucks in all of the former plenitude, a black hole pulling the scene away from the watcher self into an engulfing void.

Were we to represent Sartre's scenario in terms of a picture, the Raphael *Sposalizio* would illustrate its general formation (Figure 2). In one sense all of the architectural spaces turn towards the viewer, displaying their advertent aspects to one who stands at the place of masterly overview, with every line of flight across the cornices, flagstones, and arcades traveling in towards the sovereign spectator. But in another sense the architecture of the piazza turns towards a place where the viewer does not and cannot exist. The moment the viewer appears and takes up position at the viewpoint, he or she comes face to face with another term that is the negative counterpart to the viewing position: the vanishing point. All of the orthogonal lines across windows, doors, pavements converge there at the vanishing point where, *par excellence,* the viewer is not. The lines of the piazza race away towards this drain or black hole of otherness placed at the horizon, in a decentering that destroys the subject's unitary self-pos-

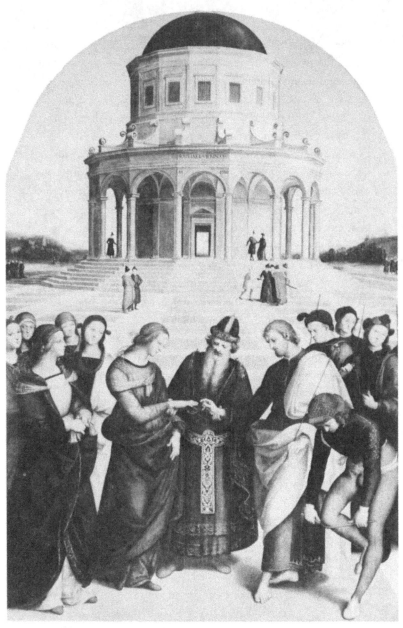

Figure 2. Raphael. *Marriage of the Virgin (Sposalizio della Madonna)*, 1504. Brera, Pinacoteca. (Courtesy Alinari/Art Resource, N.Y.)

session. The viewpoint and the vanishing point are inseparable: there is no viewpoint without vanishing point, and no vanishing point without viewing point. The self-possession of the viewing subject has built into it, therefore, the principle of its own abolition: annihilation of the subject as center is a condition of the very moment of the look.

This pictorial example is perhaps closer to Lacan than to Sartre, for in Sartre the agent that accomplishes the reversal of the visual field, its peripateia, is personal: another being, before whom I become opaque, abject, in a dialectic of master and slave. Lacan's reworking of Sartre's scenario dispenses with this personalized other.[2] His story is a good deal stranger. Lacan is away from Paris, in Brittany, out with fishermen on the open sea. On the surface of the sea are pieces of flotsam, in particular a sardine can, to which one of the men reacts by saying to Lacan: "You see that can? Do you see it? Well, it doesn't see you!"[3] The remark disturbs Lacan because he can sense a perspective in which it is untrue: the world of inanimate objects to some extent always looks back on the perceiver. What is the source of this strangely empowered *look back*? Lacan's account depends, not on the irruption of another personal viewer but the irruption, in the visual field, of the Signifier. When I look, what I see is not simply light but intelligible form: the *rays* of light are caught in a *rets,* a network of meanings, in the same way that flotsam is caught in the net of the fishermen. For human beings collectively to orchestrate their visual experience together it is required that each submit his or her retinal experience to the socially agreed description(s) of an intelligible world. Vision is socialized, and thereafter deviation from this social construction of visual reality can be measured and named, variously, as hallucination, misrecognition, or "visual disturbance." Between the subject and the world is inserted the entire sum of discourses which make up visuality, that cultural construct, and make visuality different from vision, the notion of

unmediated visual experience. Between retina and world is inserted a *screen* of signs, a screen consisting of all the multiple discourses on vision built into the social arena.

This screen *casts a shadow:* sometimes Lacan calls it a scotoma, sometimes a stain. For when we look through the screen, what we see is caught up in a network that comes to us from the outside: mobile tesserae of signification, a mosaic that moves. This network is greater than its individual agents or operators. When I learn to speak, I am inserted into systems of discourse that were there before I was, and will remain after I am gone. Similarly when I learn to see socially, that is, when I begin to articulate my retinal experience with the codes of recognition that come to me from my social milieu(s), I am inserted into systems of visual discourse that saw the world before I did, and will go on seeing after I see no longer. The screen casts a shadow *of death.* Everything I see is orchestrated with a cultural production of seeing that exists independently of my life and outside it: my individual discoveries, the findings of my eye as it probes through the world, come to unfold in terms not of my making, and indifferent to my mortality. The screen *mortifies* sight. Its terms are points of signification, chains of signifiers, that of themselves have no light. The signifier operates on light and with light, but has no light of itself, or only the light it borrows from my eye. The signifier casts its shadow of darkness across my vision, and because of that darkness I am no longer bathed in the lustre of a luminous plenitude. Into my visual field something cuts, cuts across, namely the network of signifiers. To illustrate in pictorial terms what that something is, Lacan provides his example from Holbein.[4] The ambassadors are masters of learning, in possession of all the codes of knowledge, of science and art, fashioned in their social milieu; but their visual field is cut across by something they cannot master, the skull which casts itself sideways across their space, through anamorphosis (Figure 3).

Figure 3. Hans Holbein. *The Ambassadors,* 1533. London, National Gallery of Art. (Courtesy SNARK/Art Resource, N.Y.)

The effect of this insertion of the screen, or skull, or scotoma, is that the subject who sees is no more the center of visual experience than the subject of language is at the center of speech. When I speak, I may try to fill each word I utter with the full meaning of my unique thought. But the fact remains that, in the social arena where I speak, the words I utter have to follow paths or networks laid down before I entered their terrain. The speaker did not create these, nor does the speaker control them. In the same way, when I see, *what* I see is formed by paths or networks laid down in advance of my seeing. It may be the case that I feel myself to inhabit some kind of center in my speech, but what decenters me is the network of language. It

may similarly be that I always feel myself to live at the center of
my vision—somewhere (where?) behind my eyes; but, again,
that vision is decentered by the network of signifiers that come
to me from the social milieu.

Lacan pushes this description further. In place of the
speaker in ordinary conversation, he invites us to consider the
speech of the analysand. The experience of analysis, as Lacan de-
fines it, forces the speaker to recognize that the words she or he
utters have their own perturbing life; that they follow paths and
chains unknown in advance, in movements that circle round yet
never reach the locus of desire or fear. Psychoanalysis *is* that ex-
perience of speaking on the field of the other. The analysand
does not stand at the center of control over these motions of the
signifier; he or she is more like their bewildered observer.
Lacan's analysis of vision unfolds in the same terms: the viewing
subject does not stand at the center of a perceptual horizon, and
cannot command the chains and series of signifiers passing
across the visual domain. Vision unfolds to the side of, in tan-
gent to, the field of the other. And to that form of seeing Lacan
gives a name: seeing on the field of the other, seeing under
the Gaze.

III

I want now to pass from the current of thought of Sartre and
Lacan to another current, the one which passes from Europe
into Japan by way of the most influential Japanese philosopher of
the twentieth century, Nishida, and which passes on from
Nishida to the writer who, at the level of translation, is much
more accessible to Western readers than Nishida himself, Keiji
Nishitani.[5] Nishitani's critique of Sartre occupies a crucial sec-
tion of Nishitani's book *Religion and Nothingness,* and it bases it-
self on the observation that with Sartre there is no radical
overturning of the enclosure of thought which treats the ques-

tions of ontology, of subject and object, from *within the stand-point of the subject.*[6] Nishitani remarks that the Sartrean *je* is capable of reaching a level of nihility in which everything that exists is cast into doubt, except the fundamental irreducibility of the *je* which does the doubting. For example, when the *je* fully understands the death of God and comes to doubt the viability of an ethics imposed on the subject from the outside, the Sartrean *je* reacts by falling back in on itself, and by struggling to locate an authenticity of the self from which ethical action can emanate directly: when the forms of ethics pass into the field of nihility and are annulled there, that annihilation is overcome by the *je*'s assertion of itself as authentic core of moral agency. The passing of ethical forms into the field of annihilation dismantles *them,* but does not dismantle the *je,* the self which reacts by redoubling the force of the self as it operates on the nothingness outside it. For Nishitani, Sartre's nihilism is half-hearted: Sartre places the universe around the self on the field of nihility, yet the self gathers force there, and uses the blankness surrounding it as, so to speak, a springboard from which to launch its own authentic operations.[7] This is to treat the field of nihility, Nishitani observes, as though it were something *against which* the self reacts—in this case by multiplying its efforts and solidifying its centeredness. What does *not* happen in Sartre's work, as Nishitani sees it, is the placing of the *je* itself on the field of nihility or emptiness: the *je* reemerges from its encounter with nihility, *reinforced* in its position as the center of its experience.

So it is with Sartre's description of vision, and the scenario of the watcher in the park. The intrusion of the other makes of the self a spectacle or object in relation to that other: the self is threatened with annihilation by that irruption of alterity on the subject's horizon. But Sartre's analysis in fact stops a long way short of the stage at which this *menace* to the subject would pass on to the field of nihility and become a full *decentering* of the

subject. Sartre's watcher is objectified by the other's gaze, just as
that other is objectified by *his* gaze: but the fundamental terms,
of subject and object, remain intact throughout the encounter. It
is as though both the watcher in the park and the intruder who
disturbs its peace were supplied with optical frames—binocu-
lars, telescopes, viewfinders—which restricted the surrounding
world to just these two poles, the watcher (now threatened by
the other's gaze) and the intruder (similarly threatened). Though
menaced by each other, neither is *fundamentally* challenged: the
subject can *survive* such a gaze, and survive more strongly for be-
ing exposed to this "alterity" which may menace the subject but
which does not in any sense actually dissolve or annihilate it.
The subject's sense of being a subject is heightened, not undone:
and this, following Nishitani's argument, is because the entire
scenario is restricted to its twin poles of subject and object.
What is not thought through is the question of vision's
wider frame.

IV

Like Sartre's *Being and Nothingness,* Nishitani's *Religion and Noth-*
ingness sets out to criticize the Cartesian self-enclosure of the
cogito. In the *cogito* the subject conceives of itself as universal
center, surrounded by the stable plenitude of an object world.
Both subject and object exist in a state of mutual confirmation
and fixity. The subject, from its position of center amidst the
world of things, looks out on its objects and perceives them as
separate *entities.* That is, objects manifest to the subject as com-
plete beings having (i) stable location in a single place; (ii) inde-
pendent self-existence (requiring the existence of nothing else in
order to exist); (iii) permanent or enduring form. The subject
looking out upon the world of entities finds itself to be an entity
symmetrical with them. Like them, the subject exists (i) in one

place and one place only. It exists (ii) independently of the objects around it, whose existence the subject is free to doubt, without that doubt entailing that the subject come to doubt its *own* existence. And the subject (iii) remains itself despite transformation in the material world. In addition to these qualities of the entity which the subject shares with its object world, the subject of the *cogito* has a further characteristic which the objects of the world do not share: (iv) a position of universal center, around which the object world clusters or converges as the subject's experiential horizon.

Like Sartre and like Lacan, Nishitani's aim is to dismantle this anthropocentric subject, but his critique differs from theirs in his insistence on the term *śūnyatā*, translated as "emptiness," "radical impermanence," "blankness," and "nihility."[8] The entity, as a conceptual category, is found unable to withstand the critique of *śūnyatā*, and transposed to the field of *śūnyatā* both the subject-entity and the object-entity literally break up. Stabilizing the entity as a fixed Form, with a bounded outline, is possible only if the universe surrounding the entity is screened out and the entity withdrawn from the universal field of transformations. The concept of the entity can be preserved only by an optic that casts around each entity a perceptual frame that makes a *cut* from the field and immobilizes the cut within the static framework. But as soon as that frame is withdrawn, the object is found to exist as part of a mobile continuum that cannot be cut anywhere. If the object is, say, a flower, its existence is only as a *phase* of incremental transformations between seed and dust, in a continuous exfoliation or perturbation of matter: at no point does the object come under an arrest that would immobilize it as Form or *eidos*. Moved on to the field of *śūnyatā* or radical impermanence, the entity comes apart. It cannot be said to occupy a *single* location, since its locus is always the universal field of transformations: it cannot achieve separation from that

field or acquire any kind of bounded outline. Because of its inseparability from the field of impermanence it cannot be said to enjoy independent self-existence, since the ground of its being is the existence of everything else. And it cannot present itself in the guise of an enduring Form.

In Nishitani's description, an object's presence can be defined only in negative terms. Since there is no way of singling out an object *x* without at the same time including it in the global field of transformations, what appears *as* the object *x* is only the *difference* between *x* and the total surrounding field. Similarly what appears as "the surrounding field" is only its difference from the object *x*. Nishitani's thinking is morphologically close to Saussure's account of the location of an individual word in a language. The word, Saussure maintains, is nothing in itself: it lacks all the properties of the entity. Rather, the word is constituted "diacritically" in its difference from its surrounding field, in this case all the other words in the language. In the same way, Nishitani argues for the diacritical existence of objects: the system of objects "knows no positive terms." Moreover, since the object field is a continuous mobility, individual objects are constituted by *différance,* deferral in time, as well. Nishitani's thinking here is close to Derrida's portrayal of *différance* in language. The meaning of a word never stands forth in full array. If we want to know the meaning of an individual word, and look it up in a dictionary, what the dictionary gives is not the meaning of that one word, but *other* words, synonyms. As one reads a sentence, one does not know what a word in mid-sentence means until one reaches the end of the sentence, and that sentence in turn changes as one moves to the next sentence, or paragraph, or page. Meaning in a sense never arrives; and in the same way, for Nishitani, being never arrives (beings never arrive). The form of the seed is already turning into the

form of the flower, and the flower is already becoming dust. The present state of the object appearing as the flower is inhabited by its past as seed and its future as dust, in a continuous motion of postponement, whose effect is that the flower is never presently *there,* any more than seed or dust are there.

Nishitani sums up the deferred/differed presence of (what had been) the entity in a series of aphoristic flashes that illuminate his text in the same way that the parables of the invaded park and the floating sardine can illuminate the texts of Sartre and Lacan (if one "gets" the aphorisms one has grasped the core argument). Two key aphorisms are: "fire does not burn fire," and "water does not wash water."[9]

It would seem to be the essence of fire that it burns; if it does not burn it is not fire. Yet fire cannot burn itself; it cannot exist in self-enclosure. Fire can burn everything that can be burned, but the one thing fire cannot burn is fire. For fire to be fire it must extend out of the enclosure of flame into the surrounding field, and only when its roots travel into its surround can it burn. Similarly, it is of the essence of water that it can wash everything that exists, and if it does not wash it is not water. Yet the one thing water cannot wash is water: it cannot exist inside the self-enclosure of the entity, circumscribed by a boundary or outline, in a single location that excludes the surrounding field. For water to be water it must percolate through that boundary and infiltrate the entity's dry surround, enter into the surrounding field across the porous filters of irrigation: only when it does so, when it leaves the self-enclosure of water, can it become water. Its existence comes to it when it has left water behind it and entered what is not itself. Its being is interpenetrated by what it is not: which is to say that things exist in the ways they do exist, under a mode of constitutive negativity or emptiness, *śūnyatā.*

V

Nishitani's analysis of vision works in terms that are very different from those of Sartre. In Sartre, the object is what appears to a subject, so to speak at the end of a viewfinder. The viewfinder or legitimate construction creates a kind of tunnel vision in which all of the surrounding field is screened out. Only that which appears within the framing apparatus—perspective, picture frame, camera—exists: the viewer on one side, the object on the other. Nishitani's move is to dissolve the apparatus of framing which always *produces* an object for a subject and a subject for an object. Passing on to the field of *śūnyatā* the object is found to exist, not at the other end of tunnel vision, but in the total field of the universal remainder. The object opens out *omnidirectionally* on to the universal surround, against which it defines itself negatively and diacritically. The viewer who looks out at the object sees only one angle of the global field where the object resides, one single tangent of the 360 degrees of the circle, and of the 360 degrees in all directions of the radiating sphere of light spreading out from the object into the global envelopment.

In the same way that Nishitani takes the object away from the framing apparatus—the picture frame, the legitimate construction—and places it on the expanded field of blankness or *śūnyatā,* so the viewer is pulled away from the aperture of the viewfinder or lens and redefined as radically dis-framed. The viewer still has his or her eyes open: the universe does not disappear. But the viewer is now a being that exists through the existence of everything else in the universal field, and not just as the subject-effect of the object that appears at the end of the viewing tunnel. Let us say that the viewer's eyes look out at a segment of the total field that surrounds the viewer omnidirectionally. This small section (or cone, or pyramid) is in fact only a fraction of the field of universal surround; this partial view can-

not be cut out of the total surround, singled out, and be made to represent the totality of the viewer's being. What enabled that narrow cone or pyramid to feature *as* the visual field was exactly the enclosure of the frame — the tunnel, the viewfinder, the legitimate construction. But once that frame is dissolved on the field of *śūnyatā* or emptiness, that narrow angle is found to be enveloped on all sides by a surround of invisibility. Once disframed, the brightly luminous segment is found actually to be constituted *within* the invisible, the dark or unmarked remainder that extends beyond the edge of peripheral vision into the space that wraps its way round behind the spectator's head and behind the eyes. What can be seen is supported and interpenetrated by what is outside sight, a Gaze of the other enveloping sight on all sides.

How can such a Gaze be represented? For surely we now stand at the very limits of representation. From this point on, only a technique which undermines the frame can stand in for the invisible which the frame excludes. And if we try to picture to ourselves the Gaze of *śūnyatā* or blankness, it must be in terms of the nonrepresentational or the anti-representational. Perhaps the clearest image of this comes from the technique which sets out both to assert and to undermine representational practice, the technique known in Japan as "flung ink."

The fullest expression of *śūnyatā* in the visual field is undoubtedly the practice that immerses itself in this concept, Ch'an painting. The landscape by Sesshū (1420–1506) is a framed image (Figure 4), and as such might suggest that we are still in the orbit of the framing apparatus — the tunneling of vision that fixes a tiny segment of the object world at one end, for a segmented viewing subject at the other. And in fact the image has no wish to transcend the facts of ordinary vision, inasmuch as these facts involve looking at the object in the form of a section or profile of the object's being. When we look at things, we do see only a tangent, and not the full radiation of light emitted

Figure 4. Sesshū. *Landscape* (detail). Tokyo, National Museum.

omnidirectionally: Ch'an does not dispute that. What Ch'an does dispute is that the profile which thus appears can be identified with the object itself, as it exists in the field of emptiness. What the image needs to include is the fact of *the object's remainder,* the other views which pass out from the object to all those uncountable places where the viewer is not. And what the image also has to acknowledge, even while it records the narrow passage of light that travels to an empirical observer, is *the viewer's remainder,* the sum of other views that the viewer excludes by assuming *this* view, the surrounding envelope of invisibility. What painting risks, in the Ch'an perspective, is the production of a false ontology in which the seer and the seen commune in tunnel vision: the subject mistaking what is only a profile of the object for the object itself; the profile, thus cut out, creating for itself a hypostasized viewing subject, pinned at the other end of the tunnel.

In the case of the flung-ink painting, Ch'an's solution is to disfigure the image, the bipolar view, by opening on to the whole force of randomness. As the ink is cast, it flies out of the enclosure or tunnel of the frame, and opens the image on to the field of material transformations that constitutes the universal surround. The flinging of ink marks the surrender of the fixed form of the image to the global configuration of force that subtends it. *Eidos* is scattered to the four winds. The image is made to float on the forces which lie outside the frame; it is *thrown,* as one throws dice. What breaks *into* the image is the rest of the universe, everything outside of the frame.

It is the same with the flung ink of Ch'an calligraphy, so rapid that the ink cannot be contained by the system of script (Figure 1). When the graphic gesture is slow, deliberate, the traces can still be held within a framework of control. The calligrapher operates *on* the character, and the character *dictates* the movements of the brush. Accelerated, the gesture comes loose from this bipolar structure of holding-in-place: the ink flies

faster than the hand can control it, and to areas of the paper or silk beyond the sway of the character's prescribed structure. It breaks free from the subject who controls it, and from scriptural form. The framework of script and calligrapher is cut across by another term that stands for everything outside their circumscribed enclosure: the rest of the universe, the field of emptiness that subtends the entities of scribe and script and annihilates them as freestanding and independent forms.

Something cuts across the field of vision, and invades it from the outside. Vision is traversed by something wholly ungovernable by the subject, something that harbors within it the force of everything outside the visual dyad. Let us call it the Gaze. But it is hardly the Gaze of Sartre, or even of Lacan.

VI

In Lacan, something cuts across the space of sight and darkens it: the Gaze. And in the flying of the inks there is an entry into the visual field of something totally dark and opaque that stands for absolute alterity: the otherness of the rest of the universe, a surrounding field that decenters the subject and the subject's vision completely. When the painter or calligrapher throws the ink, there is renunciation of all claim to act as universal center, and at the same time (*pace* Sartre) renunciation of the object as *alternative* universal center. Yet these abolitions of self and center are not accompanied by any apparent sense of menace, which may indicate ways in which Sartre and Lacan still operate from within a certain intellectual enclosure.

What seems questionable in Lacan's account of vision and painting is the paranoid coloration given to the Gaze. The Ch'an examples point to regimes of visuality in which the decentering of the subject may be thought in terms that are not essentially catastrophic. And this in turn prompts the question: if, in certain "alternative" scopic regimes, decentering is unaccompanied

by the sense of menace or persecution, why does Lacan provide only one model of vision and of painting, that of the negative or terrorizing gaze?

There seem to me two, related answers. The first concerns a rather deep uncertainty in Lacan concerning the role of cultural variation in the construction of subjectivity. Lacan's description of how the subject is formed unfolds in terms of culture: it is in the irruption of the symbolic order and of signification that human subjectivity is precipitated, and since the composition of the symbolic order and of the codes of signification are historically and culturally variable, the subject in Lacan is given by culture and history, not by nature. Nevertheless, Lacan says far more about the subject's initial insertion into the symbolic than about the subject's subsequent life there. That subsequent existence is where the variables of history, culture, and class operate, and construct the subject across the enormous array of local discourses through which the subject moves: in the workplace and the family, in the institutions of education, medicine, law, property, religion, government, and all the diverse cultural arenas of the social formation. We are certainly invited to think of Lacan's terms, the Symbolic and the Imaginary, as operating in all of these adult arenas, and not only at the stage of the subject's initial formation (in childhood). Yet Lacan's descriptions tend to privilege the genetic and formative moment, not the long and diverse elaborations of adult life. This concentration on subjective genesis and installation makes it difficult to think through the question of cultural variation. As part of this, it is difficult to think through to the cultural diversity of visual regimes, some of which may view the decentering of the subject in terms other than those of menace.

The second answer is an extension of the first: that Lacan's portrayal of the Imaginary gives a centrality to his argument that is culturally specific, not universal. Nishitani's analysis of vision is of interest because its terms are so close to Lacan: like Lacan,

Nishitani engages with Sartre as a precursor, and both regard the centering of the universe around the sovereign subject as illusion. In the field of *śūnyatā* the centralized subject falls apart; its boundary dissolves, together with the consoling boundary of the object. Nihility and blankness undo the subject's centering of the world upon itself; and, radically decentered, the subject comes to know itself in noncentered terms, as inhabiting and inhabited by a constitutive emptiness. Such decentering is a central theme in Lacan and in Nishitani; and yet their approaches are quite different. Perhaps one can illustrate their divergence by way of the skull in the Holbein, and the flung ink in Ch'an. The skull appears in and as the *protest* of the Imaginary against its own decentering, as the menace of death; the flung ink figures instead the subject's *acceptance* of decentering. The skull represents the subject's fear of dissolution, the flung ink embodies instead the subject's renunciation of a central subject position, on a field of radical emptiness where the last remains of the *cogito* are rendered null and void, literally cast out on empty air. What changes between them is the cultural construction of the Imaginary. Which suggests, finally, that Lacan's account of vision as persecuted by the Gaze, like Sartre's, itself unfolds *within the Imaginary,* an Imaginary constructed in a culturally and historically specific fashion. If so, then it is that analysis which itself needs to experience some cultural and historical decentering.

Why should I or anyone spend time wrangling over Lacan's concept of the Gaze? My own answer must be that, although I obviously have reservations about a certain paranoid coloration within it, nevertheless Lacan's account of visuality seems to me historically extremely important. It marks a fundamental shift away from the ground on which vision has been previously thought. The nineteenth century saw the rise of a theory of vision in which the truth of vision lay in the retina, in the physiology of the eye and the neurology of the optical apparatus. In the twentieth century the conception of vision as primarily a

domain of retina and light has subtended a number of key ac-
tivities: in art history, formalism; in art theory, the approach to
art via the psychology of perception, in the work of Gombrich
or Arnheim; in the construction of museums and exhibition
spaces premised on the practice of decontextualizing the image
in order to permit unmediated communion between the viewer's
eye and pure form. From these and related activities has
emerged the notion of art as a matter of perceptual purity:
timeless, sequestered from the social domain, universal. Post-
modernism has entailed moving beyond this episteme and ac-
knowledging the fact that the visual field we inhabit is one of
meanings and not just shapes, that it is permeated by verbal and
visual discourses, by signs; and that these signs are socially con-
structed, as are we.

The real discovery here is that things we took to be pri-
vate, secluded, and inward — perception, art, the perception of
art in the museum — are created socially. What is at stake is the
discovery of a politics of vision. Which is finally why one might
want to query the paranoid or terrorist coloration that Lacan
gives the Gaze. Let us say that it is a bit easier, since Lacan, to
think of visuality as something built cooperatively, over time;
that we are therefore responsible for it, ethically accountable. Yet
Lacan seems to me, at least, to view the subject's entry into the
social arena of visuality as intrinsically disastrous: the vocabulary
is one of capture, annexation, death. Against this someone else
might say: the degree of terror depends on how power is dis-
tributed within that construct once it is built, and on where one
is made to stand inside it. Under a voyeuristic male gaze, a
woman might well experience terror. And what of the beggar in
the street, or of a Third World rendered trivial and picturesque
under the gaze of colonialism? Terror comes from the way that
sight is constructed in relation to power, and powerlessness. To
think of a terror intrinsic to sight makes it harder to think what
makes sight terroristic, or otherwise. It naturalizes terror, and

that is of course what is terrifying. But what should ensue from
Lacan's portrayal of the terror of sight is analysis, analyses, many
of them, of how power uses the social construct of vision, visu-
ality. And also of how power disguises and conceals its opera-
tions in visuality, in myths of pure form, pure perception, and
culturally universal vision.

Notes

1. Jean-Paul Sartre, *Being and Nothingness*, trans. Hazel E. Barnes (New York:
Philosophical Library, 1956), Chapter 1, section 4, pp. 254-302.
2. Jacques Lacan, *The Four Fundamental Concepts of Psycho-analysis*, ed. Jacques-
Alain Miller, trans. Alan Sheridan (New York and London: W. W. Norton,
1978), sections 6-9.
3. Ibid., p. 95.
4. Ibid., pp. 85-90.
5. Works by Kitarō Nishida (1870–1945) available in English include: *Intel-
ligibility and the Philosophy of Nothingness*, trans. Robert Schinzinger (Honolulu:
East-West Center Press, 1958); *A Study of Good*, trans. V. H. Viglielmo (Tokyo:
Printing Bureau of the Japanese Government, 1960); and *Last Writings: Nothing-
ness and the Religious Worldview*, trans. David A. Dilworth (Honolulu: University of
Hawaii Press, 1987). On the relevance of Nishida in the context of poststruc-
turalism and postmodernism, see William Haver, "The Body of this Death: Al-
terity in Nishida-Philosophy and Post-Marxism," Ph.D. dissertation, University
of Chicago, 1987.
6. Keiji Nishitani (b. 1914), *Religion and Nothingness*, trans. Jan Van Bragt
(Berkeley: University of California Press, 1982), pp. 30-45.
7. Ibid., p. 33.
8. On *śūnyatā*, see ibid., chapters 4-6.
9. Ibid., p. 116.

Norman Bryson I should clarify one thing. The Ch'an examples, by Sesshū and Murata Shukō, date from the fifteenth century—I wasn't making an historical connection between the paintings and Nishitani. The illustrations I used are simply diagrams of arguments; I'm not making historical claims about the East and the West and their traditions. But since Sartre uses the visual scenario of the park and Lacan involves Holbein to diagrammatize his argument, I thought Ch'an painting might provide a visual form for Nishitani's ideas.

Rosalind Krauss When you described the gaze of *śūnyatā*, particularly in relation to the notion of framing developed by Nishitani, you said it has to do with the dark, unmarked remainder—the things that fall outside the frame of vision in its Western perspectival sense. I immediately thought of the notion developed by Merleau-Ponty in *The Phenomenology of Perception* that vision is constituted precisely by what goes on behind the head and in the body—all those perspectives that are the perspectives of the world. It is precisely his account of the phenomenology of vision that it is dependent on the sum of other views excluded by the position of the viewer, an account that he develops specifically in relation to Cézanne. I wonder—and this may be pure projection on my part—if there is not an echo of *The Phenomenology of Perception* in Nishitani.

Bryson It seems to me that Nishitani does draw on Merleau-Ponty, but the practice of flung-ink painting is obviously different from that of Cézanne. The emphasis is far more on a radical decentering of the subject, and I think that points to a difference between Nishitani and Merleau-Ponty, although in the thematic of the invisible they are close. In Merleau-Ponty there seems to be not only a desocialization of the body but also a simplification of the body—a simplification because it is still regarded as the center from which one looks out onto the world, and it is exactly this center that is cast out in Nishitani.

This leads to the question of the difference between Merleau-Ponty and Lacan. At certain points Lacan is asked if his position is like Merleau-Ponty's and, curiously enough, he says that it is. But it obviously can't be because the body in Merleau-Ponty is a unified, untroubled place of acrobatic grace and perceptual accord between subject-world and object-world, an exact fit of the incarnated subject inside the flesh of the world. And such harmony of the body in its world is precisely what *isn't* present in any theory in which the sign is seen to trouble this union. Now when I invoked my Oriental example—even though it is the only appropriate one for an argument that is in articulation with the West from the outside—it might have seemed as though I was invoking a purely gestural painting, but my point is not the pure gesturality of the Japanese work but rather the renunciation of gesturality in the flinging of ink: the gesture of the Merleau-Pontyan body, centralized in its world, is also thrown out by this flinging of ink.

Martin Jay I think it is crucial to recognize the existence in this Japanese discourse of a Heideggerian motif even more than a Merleau-Pontyan one. When Heidegger talks about the notion of *Umsicht,* of a circumspect vision, he means a vision that doesn't have any one particular vector. And when he contests the notion of enframing as part of the *Gestell* of Western science, he attacks the same thing the Japanese thinkers are attacking. His notion of *Lichtung,* of a clearing, is also the notion of a place in which truth is revealed—but not necessarily to any one eye or two eyes in any one body. The truth is revealed, and the eye is simply there to bear witness to it; this happens in precisely the way you described it in Japanese painting. Now Heidegger had an extraordinary impact in Japan from the 1920s to 1940s, and I am interested to know whether or not the figures you discussed were consciously indebted to him.

My second question concerns the issue that Rosalind just

raised about Merleau-Ponty. Merleau-Ponty seems to me to be a very important transitional figure between Sartre and Lacan, not only because he is more interested in the body and the crossing of gazes, but also because he is more interested in signs. I think it would be wrong to say that, unlike Lacan, Merleau-Ponty only talks about the body. In his last writings he actually cites Lacan ("the unconscious is structured like a language"), and there are at least gropings toward a structuralist view of language. I do, however, agree that the later Merleau-Ponty is much more optimistic about visual interaction than Lacan, who shares with Sartre a much more pessimistic, perhaps even paranoid view. But Merleau-Ponty also introduces elements which lead us toward Lacan, including the linguistic mediation of the viewer and the viewed in the flesh of the world.

Bryson I would agree with both those emphases. About the connection between Nishitani and Heidegger: it is via Nishida, more than twenty of whose students, including Nishitani, went to study with Heidegger. But actually I have a question for you. It has been very much on my mind—this issue of the paranoid coloration given to visuality in different French traditions of the seventeenth, eighteenth, and twentieth centuries. I am impressed by what you write about this tradition in the twentieth century [in "In the Empire of the Gaze"], though I also have reservations, especially in relation to Foucault. Nevertheless, I wonder whether Lacan's rhetoric of decentering as paranoid and terroristic does not participate in that tradition.

Jay I think his early discussion of the "mirror stage" as the source of a false notion of the integrity of the ego does reflect a general hostility to the gaze as a source of ideological notions of selfhood. But in the later *Four Fundamental Concepts of Psychoanalysis,* a very difficult text, Lacan perhaps moves away from an idea of vision as strictly paranoid and terroristic, and this may be why he draws on Merleau-Ponty—to nuance the problem

somewhat. I agree that Foucault can also be seen to nuance the simply hostile tradition; Merleau-Ponty obviously does. One has to avoid making it black and white. But I think that Lacan must be understood largely in the tradition critical of vision. Althusser, too, when he talks about ideology as produced by the gaze, by the mirror stage, draws on Lacan and attacks vision. Christian Metz, when he talks about the scopic regime of the cinema, also draws on Lacan to denigrate vision as well. So I think they are all part of a larger story. Lacan gets it, as you said, to a great extent from Sartre; Sartre's view of vision is very seminal for a lot of these thinkers. One might also mention Bataille—there are many interesting connections between Bataille and Lacan—and Bataille has a fascinating critique of the primacy of sight in such works as his pornographic novel *L'histoire de l'oeil* and his essays on vision. That would have to be part of the story of Lacan's attitude toward vision as well.

Jonathan Crary Norman, could you clarify something for me? Initially you said you didn't want to set up an opposition between a Western and a non-Western tradition, and then you said you could only have picked a Japanese example to incarnate this other tradition. Would it have been possible for you to have chosen an example from, say, twentieth-century Western modernist art practice, or is it *a priori* impossible?

Bryson No, it's not a matter of impossibility; it was just a question of what images could give the best form to these arguments. There is no cultural enclosure that makes it impossible for a Western art practice to embody the concepts Nishitani works with.

Crary Let me then pose a rather crude, formalist-type question. If a Franz Kline had been shown, what would one have said?

Bryson I was thinking more of Pollock's work, but I couldn't use it. There is an essential difference between Pollock and the flung ink

of Ch'an painting, and it is important to get it right. Although there is a renunciation of control over form in an image that involves randomness, it is nevertheless recuperated in Pollock's painting: central subject positions return in so many ways—for example, in the way randomness becomes his style, so that exactly at the point where self-control is abandoned it is reinscribed as his personal style. That is one place in which there is a recentering at the very moment of a decentering. Another way is the manner in which Pollock drips paint: the drips overlay one another to produce eidetic depth—one looks at Pollock as if through various screens—and it is exactly that eidetic depth within the frame that is irrupted and broken by flung-ink. So for those reasons—but not because of any uncrossable cultural enclosure—it seemed more sensible to choose Sesshū rather than Pollock.

Jacqueline Rose I have a reply to Martin, one that relates to questions I have about a number of things we have discussed so far today. I want briefly to historicize Lacan's hostility to vision: it needs to be located in the very origins of psychoanalysis, in the images of Charcot's hysterics at the clinic of the Salpêtrière. It is a perhaps overworked example but one that, especially in the context of the images of women shown to us by Rosalind, may reinvoke the importance of questioning the immediacy and availability of the image as the immediacy and availability of the body of the woman.

My second point is in response to Norman regarding the paranoia of Lacan's model: I'd like to historicize that as well. What Norman calls the terror or paranoia of vision again comes in response to a specific historical moment. That moment is perhaps best summed up in the concept of "genital oblativity," which (to quote Lacan) is "now being struck up everywhere to the tune of salvationist choirs." That is, the negativity of the visual and the negativity of the psychic were part of a critique not only of ego psychology but also of a social demand of the couple on the couple to be *the* couple.

Jacqueline Rose

SEXUALITY AND VISION:

SOME QUESTIONS

I was asked to speak on the question of sexuality in vision. I
want to start by stretching that brief into the wider domain of
how psychosexuality is being mobilized in certain accounts and
definitions of the postmodern, and ask what image of the psyche
is being deployed, before bringing that back to the question of
how the psychoanalytic understanding of the visual field is being
used, what I see as some of the problems, and then how those
problems might relate to recent areas of artistic practice which
do not necessarily refer directly to, or use, psychoanalysis but
which seem to inherit a related set of questions. I also just want
to draw our attention to these practices as they strike me as
forming some of the most crucial and innovative areas of our
contemporary cultural and political life.

I think it is becoming clear that many of the debates about
postmodernism and totality turn on a fundamental psychic
trope. From Deleuze and Guattari's *schizo-analyse* to Jameson's
cultural logic of capital which is in fact an a-logic (that is, the
loss of the possibility of logic itself), to Lyotard's "paradoxol-
ogy," the crisis of the totality takes its reference from the idea
of a psychic breakdown in which it recognizes, or rather fails to
recognize, itself. I don't want to get into the debate about the la-
menting or celebration of that felt loss of totality and narrative
which characterizes respectively the positions of Jameson and
Lyotard. But I do want to stress the way that schizophrenia
works as a recurrent image of the social and the way that, in the
case of Jameson quite explicitly, this is in deliberate counterdis-

tinction to what he refers to as the "hysterics and neurotics of Freud's own day."[1] In the article in the collection *The Anti-Aesthetic,* edited by Hal Foster, which I am sure you all know, Jameson illustrates this argument with an extract from the *Autobiography of a Schizophrenic Girl.*[2] Crucially for this context, this is an argument about visual perception. The schizophrenic girl is there to illustrate the loss of perceptual coordinates in the postmodern world, its hallucinogenic hyperreality, an undifferentiated vision of the world in the present which deprives the subject of the ability to locate her or himself in either space or time. If the postmodern subject is schizophrenic, she or he is also paranoid, and the image for this too is one of distortion in visual space: "the glass skin repels the city outside; a repulsion for which we have analogies in those reflector sunglasses which make it impossible for your interlocutor to see your own eyes and thereby achieve a certain aggressivity and power over the Other."[3] The image fulfills rather graphically, therefore, that paranoia of the visual field which Norman Bryson has just described. One of the things that strikes me about these images, however, is their curious desexualization, or rather the way that this absorbing of sexuality into the visual field closes off the question of sexual difference. Schizophrenia and paranoia operate as the *form* of postmodern subjectivity, but they have been divested of their *structure,* by which I mean the structure of sexual difference, whose vicissitudes and misfortunes, at least in the psychoanalytic terms on which Jameson partly draws, precipitates the disorder into place. This is in one sense an old story, but it might nonetheless be worth noting the form of its repetition here. Jameson states quite explicitly that he is detaching the psychic mechanism from the paternal function with which, for Lacanian psychoanalysis, it is linked. What we have therefore is an account of the postmodern as a form of breakdown which could be said to imitate that breakdown by foreclosing the paternal metaphor from the account. For a feminism which has seen

one of its chief objects as an exposing of the force and effects of that metaphor, the omission can be felt like something of a political disenfranchisement — unless one wants to argue that it is the psychoanalytic account itself that inscribes and reinforces that metaphor, holds onto it precisely in the face of its historical demise (the feminist version of the celebration of the end of all narrative form).

Now I don't want to put myself in the position of just "correcting" Jameson on this, or reversing his deliberate omission, although I do think it has serious implications for his own cultural critique — the omission in turn of any women artists from his account of postmodern cultural production, and more specifically of those who might be said to make the representation of sexual difference, or sexual difference *as* representation, their chief object of concern (might this not have something to do in turn with the negativity of the account?).[4] What interests me here more is the concept of representation that is at stake, for it seems to bring with it a kind of nostalgia for direct and unmediated vision: hallucination and the image of the glass skin and reflector sunglasses are being critically juxtaposed to a moment or an epoch when vision was direct and possible, when the viewing subject looked out on and greeted the world, and greeted too, without perversion or aggressivity, the other human subjects who peopled it. To stress this can be seen as the reverse move to Norman Bryson's, insofar as I am describing the *discarding* of the paranoid instance from the general theory of vision at the very same moment that the sexual dimension is also lost to the account. Behind this nostalgia for unmediated representation there is, perhaps more crucially, the relegation of psychosis to the status of historical contingency and a corresponding idealization of psychic life. The use of the psyche as metaphor of the social leads, paradoxically, to a strange innocenting of both the psychic and the sexual, that is, a loss of the psychic dimension at the very moment that it is being evoked.

What this suggests is a larger problem, one I would include myself in: we have not perhaps thought enough about the status of psychoanalysis in cultural discourse, about whether it is being *applied* to other aspects of cultural and political life, whether it is being deployed as a *metaphor,* whether it is being used as a *historical* reference point for transformations of cultural and representational form. Many of the points that have been made so far today about homologies between psychoanalysis and philosophy in relation to the visual image might reflect something of that concern. In relation to the visual image specifically, there seems to be an inverse but related position, one which locates what is radical, or available for a radicalization, as regards representational practices in the disruption of the image's relation to itself, in its "knowledge" of the necessary failure of its relation to its objects, that is, in the extent to which it foregrounds the indeterminacy of the linguistic and/or visual sign. It can be described as a return to a constructivist ethic, or as a retrieval in new form of the possibilities for representation of a pre-Renaissance or nonperspectival organization of the visual image. The politics of this practice, or of the practices it addresses, then lies in their withholding or refusal of perceptual mastery, which mastery is identified as an ideological—as *the* ideological—myth. The question this raises is a similar one to the question I raised above, and that is the nature of the positive term that is mobilized once psychoanalysis is brought in to reinforce or expand this essentially deconstructive account. For aren't we equally at risk of reifying the concepts of desire and the unconscious, idealizing them as the site of an endless displacement of body and of language, reading their anguish as our pleasure, discarding therefore the specific vicissitudes and misfortunes of the psyche from this psychopolitics of the sign? We have seen something of this in many of the terms used today—"the ecstasy of the *folie du voir,*" "the excitement and wonderment of the body," "the beat, pulse, or throb" (although in this last example, the terms could per-

haps be contrasted with the configuration and delineation of fantasy positions which Rosalind Krauss, following Lyotard, also described). For this realm of the not-yet symbolically coded, of representation which is not yet, or no longer wishes to be, tied to the centering of subject and vision, is the place of the part-object, the projectile, the place of splitting, not only of the ego, but also of the drives—all dimensions which, as Norman Bryson has argued, are indeed general characteristics of the visual in Lacan, if not also in Freud, but which start to fade from the image when it is in the name of a radical othering of vision that the reference to psychoanalysis is being deployed. The physiology of vision that Jonathan Crary so graphically describes may well be an attempt to give a figure to that space, but I would still suggest that in so doing it refines—can only refine—some of the most difficult and unmanageable, for theory as for subjects, aspects of the psychic dynamic it evokes. What body are we dealing with here? What desire? (Compare again the terms of today's discussion—"voluptuous succumbing," "desire as erotic and metaphysical," "a charge and discharge of pleasure," "the body as thickness.")

Another way of putting this would be to say that Jameson pushes back into a psychosis of the visual field, whereas these other accounts remain more in the framework of a neurosis of vision. In the first, therefore, aggressivity without the sexual structure; in the second, the form of desire and its othering, but without aggressivity and its defense.

Furthermore, how much can we invest in those concepts when we notice the forms of sexual differentiation in which they so readily and repeatedly find themselves caught? Thus in *Tradition and Desire,* Norman Bryson saves Ingres's *La Grande Odalisque* from one feminist critique by its self-disruption into *jouissance* (one might argue that it is precisely the image of the woman that reencodes that disruption into form, gives the viewer a measure of retrieved control).[5] And the images that Rosalind Krauss has

shown us today—the zootrope, which turns its beat of represen-
tation and its doubling on a girl trapped within its space, or the
cartoons of Picasso, whose multiple repetitions gradually body
forth as their most appropriate image the genitalia of the man
and then the fundamental copulatory pair—are each brilliant ex-
amples of the way sexual difference, if you give it half a chance,
will take over any subversion or mutation of visual space. In re-
lation to the visual image, concepts like desire seem, therefore,
to be hemmed in on either side—by the psychic economy which
they both draw on and partly suppress, by the always-waiting
structure of sexual difference which gives to their attempted
bodying and disembodying the most predictable and stereotyped
of sexual tropes. Another way of putting the first part of this
comment would be to say that the relationship of psychoanalysis
and the visual image may have got caught in the terms of its own
reference, for to argue that there is a sexuality of the visual field
is not—or should not be—the same as saying that sexuality can
be absorbed into, or exhausted by, the field of vision.

If I stress this, it may also be because I think there is a
more general shift taking place in the way that psychoanalysis
and cultural politics needs to be thought. For that critique of the
ideology of mastery, for which the visual field was seen as the
predominant site, can be traced back to the moment of Barthes's
Mythologies when ideology was seen to function as interpellation,
that is, as the more or less comfortable calling up of subjects
into an essentially bourgeois and collective psychic space.[6] To-
day, as the terms of our collective imaginary move into a mode
which is both more directly repressive (repression rather than
interpellation as one of the chief mechanisms of the right-wing
state) and more extreme and hallucinatory in its fantasmatic
forms (the resurgence of authoritarianism and the phenomenon
of the New Right), neither the category of interpellation nor the
forms of sexual disruption we thought to oppose to it seem ade-
quate. As long as the dominant ideology called up a facile image

of sexual self-recognition, identity, and ease, we could oppose it with a disrupted and disrupting body and desire. But today that ideology works as much on the edge of terror and violence as it does with increasingly prescriptive sexual norms, that is, terror and violence as something both abhorred (in England the increasing force against, and definition of, "terrorism," the assault on television violence) and desired (the Falklands war and the annual vote on capital punishment). Today, therefore, the dominant ideological configuration, or crucial parts of it, seems to draw on an aspect of the unconscious which was missing from either side of the earlier account. This forces us to rethink the question of the unconscious and politics since nobody would, I think, want to ascribe to unconscious violence the potentially radical force which we tried to locate in that earlier concept of sexual desire, the concept that has been moved across—via Barthes—into the analysis of visual space. In this context, it is interesting to note that if psychoanalysis is the intellectual tabloid of our culture ("sex and violence" being its chief objects of concern), then we have recently privileged—sought indeed to base the politicization of psychoanalysis on that privilege—the first over the second. For good reason, since violence does not present itself for political assertion and mobilization in the same way. It might also be the case that this problem simply reveals the limits of any psychopolitics based on an assertion of the unconscious—or on the unconscious as counterassertion—as such. In relation to visual analysis, the unconscious of the image, or what has come to be read as the unconscious of the image, has yet to take on the more negative and troubling underface of its own category of desire.

I have already mentioned that both of the theories I have concentrated on here—the postmodern "loss" of subjectivity as the end of political space, and the politics of visual space as the very same demise or self-undoing of the subject—recognize a fundamental loss of innocence, or of reference, in relation to the

linguistic sign, whether this is experienced as cause for celebration or lament. In relation to psychoanalysis, that loss can alternatively be described in terms of the category of the ego, either as the loss of a needed integration of selfhood or as the fundamental misrecognition of the subject who persists in his conviction that he is precisely a subject in place. These two positions have historically presented themselves as antagonistic; the disagreement between them merely repeats itself in the different accounts of, and reactions to, the postmodern by Jameson and Lyotard. But how viable, finally, is this opposition in some of its more polarized versions or forms? For one cannot of course reify the ego any more than its opposite, as if the one could in fact exist without the other as its necessary and antagonistic term. If Lacan says in *Seminar II* that the point of having analysts is to have "subjects such that the ego be absent," his work must nonetheless be read as the tracking of the ego—necessary illusion, master, dupe, and bait of his practice—through which subjects misrecognize themselves into place.[7]

If there can be no idealization of the unconscious, therefore, it is not just because of the negative of its contents, but because without the category of the ego to which it is opposed, the unconscious would not even be available to thought. One solution is to identify that ego with the fantasy of the post-Cartesian Western subject. But that unconscious? Or that body "in all its physiological possibilities"? It can easily seem to escape that same recognition or demand, holding itself up as the ideal dispersal of subjectivity across visual space (while paranoia then becomes just another turn of the Western subject). We saw the problem in the response to Norman Bryson's paper, when the corpus of Western philosophy started to move in to reclaim the very visual dimension that he was so carefully attempting to locate somewhere else. Theoretically, no more than psychically, therefore, can we take one half of that dialectic in the search for alternative visual forms.

Something of this tension, and of the need to think about it differently, was brought home to me particularly strongly at an event on Cultural Identities held at the Commonwealth Institute in 1986, which sought to bring together black and white filmmakers and theorists in relation to the idea of a politically avant-garde film, and it is what I want to end with today.[8] (We should note here the event organized by Yvonne Rainer, which took place concurrently with this vision symposium and which produced a similar set of encounters between filmmakers and critics of the First and Third Worlds.) What struck me most forcibly was the set of analogies and differences in the way the problem of racial and sexual identity and difference was being posed in relation to representation and, more specifically, to the visual representation of film. For it has been the strength of the feminist challenge to dominant cinematic institutions that it has located its perversion of the sexual in the very framing and encoding of the image, a challenge which has as its logical consequence a distrust of the possibility of cinematic representation itself. Yet, for more than reasons of the impasse to which this has led, feminist and other forms of political cinema have not wanted to discard the image as available for political self-recognition and critique. This means that feminist filmmaking is caught in a paradox which was succinctly put by Felicity Collins in a recent edition of *Screen:* "a political cinema must be a fetishist's cinema,"[9] must, as I read it, deploy the very forms of identification through the image that it has itself designated as corrupt. The problem is brilliantly focused by Peter Gidal's film *Close-Up,* which follows its own (non)filming of an object world with a blank leader sequence whose soundtrack is the voiceover of Nicaraguan revolutionaries—a film which therefore gives you that systematic refusal of identification with the visual image for which Peter Gidal is best known and then doubles it over, at the point of political affirmation, with the voice (soliciting, one could argue, no less full an identification) of political truth.

And this question of identification, and something of its paradox, was also present in the discussion of the politics of race. It was argued by Paul Gilroy, opening the event, that the current forms of racism base themselves on cultural rather than biological difference, but still on difference as total difference (extolled and used for purposes of degradation at the same time); and yet it was also argued that the imperial image most urgently in need of deconstruction is the one that denies all difference in the name of an international "family of man" (the deconstruction of this image was the basis of the slide-tape *Signs of Empire* made by the Black Audio Film Collective, one of the films shown at the event). Again, and without reducing them to each other, the link can be made with a feminism which repudiates a difference which always and necessarily encodes itself as sexual difference, and yet rests on that difference as the only place from which it can construct political solidarities, the only place from which it can in fact speak. In relation to the black filmmaking represented at this event, it became clear that there could be no political filmmaking that did not take up the very images that it simultaneously designated as corrupt, whether directly as in *Signs of Empire* or in the more documentary form of Sankofa's *Territories* which used, while also undoing by double commentary, interruption and repetition, the documenting of a history that it was still—despite, or through, that deconstruction—trying to retrieve.

The point of mentioning this event and these films is not just to add racial to sexual difference, as if to imply that psychoanalysis could be modified by a wider cultural recognition which would balance the attention it pays to sexuality and identity above all else. To suggest that would be to disavow the fact that psychoanalysis does indeed place sexuality at the heart of psychic organization and in the most fundamental dynamic of the sign. Rather, it is to stress the ways in which that very dynamic, and the questions of the image and identification to which it is at-

tached, is being reformulated and inflected in films which are in-
tervening into cultural practice in the name of a politics of both
sexuality and race.

Thus Sankofa's more recent film, *Passion of Remembrance,*
takes up these two issues, and then mixes the surreal and *vérité*
at the level of cinematic form to represent their incommen-
surability *and* their relation: the direct address to camera by the
woman narrator, located in a quasi-surreal space, from which
she interrogates both the spectator and the male comrade who is
allowed, in the only ever partial form of a dialogue, to enter the
visual field—all techniques which deconstruct the positionality
of the spectator as controller of the field of vision, and genders
quite explicitly that deconstruction; and then the documenting
as domestic and social detail of urban black life, the politics of
sexuality given here as the story of the confrontation of genera-
tions, in the representation of homosexuality, in the sexual self-
fashioning of the young girls. This is a film whose political force
stems from this inmixing, from its refusal to settle the question
of representation, in the way that it uses simultaneously what
have been historically two antagonistic cinematic forms. As if
one of the questions which race poses to sexual politics in the
field of representation was neither that of addition nor supple-
mentation, but more a collision of two types of visual space: a
story to be told alongside the radical distrust and undoing of the
possibility of story—of the possibility of containing all those
forms of antagonism within the visual field of the story or narra-
tive as such. It seems that the sexual and political identification,
what is both a necessity and a refusal of identification within the
available visual and psychic parameters, can only be represented
in the two forms of visual space. This is not, I hope, to appro-
priate these films, but rather to note how the introduction of ra-
cial politics into visual space, a racial politics which is also a
sexual politics, reconfigures the relation of image to identity, of
identity to its undoing—reconfigures what we might call, echo-

ing Norman Bryson's terms, tradition and desire. I also wanted to end with this because of where I am talking, the Dia Art Foundation, which seemed an appropriate place to introduce these films.[10]

To sum up the two points which I have been arguing today: First, that the use of psychoanalysis in relation to the visual image is in danger of evacuating what is most psychically difficult from the concept of the unconscious and desire. This seems especially important insofar as it is these very aspects of the unconscious which seem to be mobilized by the worst of right-wing fantasy in our wider contemporary political life. Secondly, that this is the precondition of a reification of the unconscious over identity—an accusation *against* identity—which cannot be sustained in the form of this opposition psychoanalytically, nor if we look at some of the most challenging interventions into what has come to be defined, and for some lamented in all its cultural manifestations, as the postmodern world.

Notes

1. Fredric Jameson, "Postmodernism or the Cultural Logic of Late Capitalism," *New Left Review* 146 (July-August 1984): 63.

2. Fredric Jameson, "Postmodernism and Consumer Society," in *The Anti-Aesthetic: Essays on Postmodern Culture,* ed. Hal Foster (Port Townsend, Wash.: Bay Press, 1983), p. 120.

3. Jameson, "Postmodernism or the Cultural Logic of Late Capitalism," p. 82.

4. See Jacqueline Rose, "'The Man Who Mistook His Wife For a Hat' or 'A Wife Is Like an Umbrella'—Fantasies of the Modern and Postmodern," in *Identity: The Real Me* (London: Institute of Contemporary Arts, ICA Documents, no. 6, 1988); also in *Universal Abandon? The Politics of Postmodernism,* ed. Andrew Ross (Minneapolis: University of Minnesota Press, 1988).

5. Norman Bryson, *Tradition and Desire: From David to Delacroix* (Cambridge: Cambridge University Press, 1984), pp. 136-137.

6. Roland Barthes, *Mythologies* (1957), selected and trans. Annette Lavers (New York: Hill and Wang, 1972).

7. Jacques Lacan, *Le séminaire de Jacques Lacan,* Vol. 2: *Le moi dans le théorie de Freud and dans la technique de la psychanalyse* (Paris: Éditions du Seuil, 1978), p. 287. The quote continues: "It is an ideal of analysis which of course remains virtual. There is never a subject, a fully realized subject, without ego, even though it is what one should aim to obtain of the subject in analysis" (translated by Sylvana Tomaselli, *The Ego in Freud's Theory and in the Technique of Psychoanalysis* [Cambridge: Cambridge University Press, 1987]).

8. The papers and discussions at this event have been published in a special issue of *Undercut,* entitled *Cultural Identities* (no. 17, Spring 1988), edited by Nina Danino and published by the London Filmmakers' Coop.

9. Felicity Collins, "A (Sad) Song of the Body," *Screen* 28, no. 1 (Winter 1987): 80 (special issue entitled *deconstructing 'difference').*

10. For other discussions of *Passion of Remembrance* and of the work of Sankofa, see "An Interview with Martina Attille and Isaac Julien of Sankofa," in *Young, Black, and British: A Monograph on the Work of Sankofa Film and Video Collective and Black Audio Film Collective,* by Coco Fusco (Buffalo, N.Y.: Hallwalls, 1988).

Martin Jay I want to express my support for your powerful critique of an idealization of the psyche as some sort of antidote to social and other types of alienation and dislocation. We have seen many attempts in the twentieth century to turn Freud in that direction—from Wilhelm Reich to Herbert Marcuse and Norman O. Brown. I think we are now rather less inclined to do this, though it is clear that with Deleuze and Guattari and others there are still versions of this attempt. But I am also nervous about the opposite inclination, which is to accept the paranoid view of the psyche, or of vision in the psyche, that Norman talked about in relation to Lacan. I think we have to find some way to articulate varieties of visual-cum-psychic interaction which are neither utopian and filled with a plenitude that is easy to dismiss nor somehow equivalent to all the types of non-plenitudinous alienation. The task is to come up with some sort of articulated register of visual-cum-psychic experiences—which include of course the gender dimension—that would allow us to make discriminations. We ought not fall into the either-or of a perfect plenitude—the Jameson problem—or some sort of overly tragic psychoanalytic position in which nothing really can be changed (which of course can also be read out of Freud). This is a great task, and I don't have any solutions. But I wondered what thoughts you might have about an intermediate range that would avoid such an either-or.

Jacqueline Rose I think I agree. I return to the negative dimension for two reasons: one is because there is a certain feminist interest in pre-Oedipal forms of sexuality as that which we can juxtapose to the dominant copulatory pair. The problem here is that it has to evacuate certain negativities, negativities which have then returned in debates about sexuality and sexual vio-

lence within feminism itself. It is a complicated issue in relation both to discussions of another politics and to the resurgence of right-wing fantasies, which is the other reason why the issue of psychic negativity seems politically important. These right-wing fantasies act according to a paranoid trope (militarism, the Cold War, the Falklands, capital punishment, the Bomb, South Africa, etc.), and these paranoid images serve to secure an increasingly repressive state apparatus. So I'm not posing what an ideal form of medium subjectivity might be; rather, I want to ask where are the flashpoints of the social and the psychic that are operating most forcefully at the moment. It is that which we need to understand, and in this context to discard the paranoid aspect of the Lacanian account of vision would be unfortunate.

Incidentally, when you talk about Lacan's paper on the mirror stage, you take it out of the context of the paper next to it, which is "Aggressivity in Psychoanalysis." The idealization of the ego, which then everyone can set themselves against, is only possible because that other half of his argument has been discarded. And that is not an exclusively visual problem; it is also tactile, so I'm not sure we can mobilize touch as a solution.

Norman Bryson I think you are pointing to some very deep rhetorical tropes that cut across all of us. One of these has to do with our celebration of "alternatives"—our desire here to find other scopic regimes (is it going to be Dutch? baroque? Japanese?), to make them idyllic and to take all of the difficulty out of them. And a revised, neutralized unconscious is one of the idyllic fictions that result. To what extent would a revival of Merleau-Ponty, or a return to phenomenology, be a perpetuation of that idyllic, undifficult world?

Rose I didn't think people wanted to revive him. I thought the idea was that at the very point where one thinks one has got somewhere else one has simply gone back to phenomenology.

The problem is that this too can be set up as an "alternative"—the notion of the physiology of perception seen as an otherness in phenomenological terms. This is one reason why there was so much interest in interrogating the visual image via psycho-analysis—it became a search for an alternative visual register. But as soon as one begins to locate an alternative—which I thought you did beautifully in your flung-ink examples—then references start flooding in to Heidegger, Merleau-Ponty, etc., and suddenly this otherness belongs to a network which is the very corpus of Western philosophy and its institutional effects. Also, from where can we talk about this otherness? It is the same problem as that of the universality of psychoanalysis. What would be a non-Eurocentric response to that question? For to say that psychoanalysis does not, or cannot, refer to non-European cultures, is to constitute those cultures in total "otherness" or "difference"; to say, or to try to demonstrate, that it can, is to constitute them as the "same." This is not to say that the question mustn't still be asked.

Audience (Sanford Kwinter) I'd like to address my question to Norman and to push it in the direction of Jonathan's earlier question. I appreciated your exposition, especially insofar as it seemed, at least potentially, to be a construction of a typology rather than a comment on an essential opposition between a Western and an Eastern "vision." Yet for me the interest of any typology is not to erect rubrics to which one can then assign various objects, but rather to understand that any object manifests distinctions within itself which the typology can then establish and analyze. So to me the power of your paper lies outside the specific proposals that you made; it lies instead in the heuristic capacity of your typology: in its capacity to be applied to "any object whatever" irrespective of tradition, or, for example, to fold these different ideas back into our own Western tradition, to define objects within this tradition and to understand the ways in which the elements represented by this typology play themselves out in any one of them. It is not necessary, it seems to me, to have gone to a Japanese Heideggerian to discover ideas which are finally quite Western ideas, or which are not altogether different from quite classical Western types of thinking immanence, for example.

Let me then ask these two questions. First of all, would you like to comment on the historical antecedents of this typology already at work in Western painting, especially modernist painting? One could, for example, elaborate a theory of modernity based on this typology. It would consist in showing the shift in emphasis or mixture that one finds in the twentieth century as different from the mixtures one finds before then. It seems to me that in some such approach one might find—to address your question, Jacqueline—an alternative to the search for alterna-

tives, not from outside but, precisely with the aid of this applied typology, from within, where one can see the field as constantly producing, perhaps microscopically, little alternatives, if you like, shifts and changes and mixtures within some kind of modern immanence. Second, do you see in Western culture or the Western philosophical tradition elements or precursors of these ideas, especially those that you have here identified only with examples from the East?

Norman Bryson If one generalizes the ideas away from the Ch'an tradition in which they are embedded, then one will begin to find analogies, but Ch'an is an independent philosophical tradition in its origins.

Kwinter I don't want to look for analogies. I want to know to what extent this typology can be brought back and activated within the Western—or any other single—context, and whether or not you can identify subtraditions within the Western philosophical tradition.

Bryson I'm not sure I'm producing a typological argument; that's the difficulty I have with your question. If I were, then it would be very interesting to look not at Japanese traditions but at Western subtraditions or moments and practices disengaged from Cartesian perspectivalism. But I don't think my argument is typological; it is dealing very specifically with small sections of a text of Lacan, of a text of Sartre, and of a book by Nishitani. I don't see where I'm mobilizing typologies that would make one quest for Western examples rather than Eastern ones, whether micro-examples or large totalities. It's not an argument that has to do with great blocks of art or even thought.

Kwinter Clearly it is I who have introduced the question of ty-

pology, but having done so I am surprised you have not taken me up on it—for I know you are trying to stay away from essentializing these two traditions. It was really two different kinds of vision, each with their own correlative space, that you wanted to distinguish.

Bryson Or three different ways of thinking decentering: Sartre, Lacan, Nishitani.

Kwinter So for you neither Western art nor Western philosophy suggests internal contradictions of vision?

Bryson As soon as a step is made outside of the Western tradition—and here a step not very far outside because those concepts are cycled from Heidegger and others—it seems as though one is invoking enormous totalities and worlds, and I really wasn't. If there is a misunderstanding here, it points to the powerfulness of the tropes that totalize "the West" or even a "Cartesian perspectivalism."

Audience Can you specify any other artists who are examples of this Japanese idea of emptiness?

Bryson So many, so many. But I wasn't talking historically.

Audience (Catherine Liu) I want to comment on this exchange because I find it rather disturbing. I think if Norman had chosen a Western art object as his example we wouldn't be forcing him to draw other examples from the body of Western art. If he had shown us a Franz Kline we wouldn't be asking him if there are other artists that manifest this decentering. Here we are in our strange igloo looking out through little windows. I think the resistance that we have to the Oriental object that was shown is

indicative of a whole theater of magic that we get into when we deal with the other—and this other is not *that* much other of an other.

Norman Bryson is the author of three books, *Word and Image* (Cambridge University Press), *Vision and Painting: The Logic of the Gaze* (Yale University Press), and *Tradition and Desire: From David to Delacroix* (Cambridge University Press), and editor of a collection of poststructuralist texts on art, *Calligram* (Cambridge University Press); he presently teaches at the University of Rochester.

Jonathan Crary teaches art history at Columbia University, where he is currently a fellow in the Society of Fellows in the Humanities; co-editor of Zone, he will soon publish a book on the observer in the nineteenth century (MIT Press).

Martin Jay is professor of history at the University of California, Berkeley, and author of *The Dialectical Imagination* (Little, Brown), *Adorno* (Harvard University Press), and *Marxism and Totality* (University of California Press).

Rosalind Krauss, co-editor of *October,* is professor of art history at Hunter College and the CUNY Graduate Center; her books include *Passages in Modern Sculpture* and *The Originality of the Avante-Garde and Other Modernist Myths* (both MIT Press).

Jacqueline Rose teaches at the University of Sussex; she is the author of *The Case of Peter Pan, or the Impossibility of Children's Fiction* and *Sexuality in the Field of Vision* (Verso), and editor (with Juliet Mitchell) and translator of *Feminine Sexuality: Jacques Lacan and the École Freudienne* (W. W. Norton).

Printed in the USA
CPSIA information can be obtained
at www.ICGtesting.com
JSHW011753220224
57904JS00004B/151